EXPLORING KITTENS II

story & photos by
Nobuo Honda

 Heian

First American Edition by Heian International, Inc. 1982

Heian International, Inc. P.O. Box 2402, South San Francisco, California 94080 U.S.A.

ISBN: 0-89346-201-2

Printed in Japan

My name is Mama, and I am one of three cats who rule the house where we live. I came here as a kitten when my mother sought shelter under the front porch for me and my brothers and sisters. We were sick and starving—too weak to travel any further. Mother left us under the house every day while she went out hunting for our meals.

Soon we were discovered by the owner of the house. He tried to befriend us but thought better of it once he found out how vicious Mother could be with her teeth and claws!

Later, we began to find delicious food left under the porch; we ate it and quickly grew strong and healthy. By this time, we had become accustomed to the people who also occupied our house. When winter arrived, we were quite happy to move into the house to escape the cold. Again, the people in the household tried to become friendly with us—and again we rejected them in no uncertain terms! As a result, we finally reached a truce of sorts—we ignored them and they ignored us. Only Mother continued to run from any human who approached.

After a while, I found a room on the second floor of the house that seemed to be uninhabited. Strangely enough, there was even a dish of delicious food in the room! So we moved in and claimed the room as our own.

One day, Mother failed to return from one of her outdoor forays. Soon afterwards my brothers and sisters wandered off too, and I alone was left in the house. Though I missed everyone terribly, I had become so accustomed to life in the house that I never even thought of leaving. My only problem was that I still did not like people!

In the spring of the following year I gave birth to a litter of kittens. The human family thought my kittens were so adorable that they tried to pet them. Needless to say, I put on quite a show—my hissing, growling, bared teeth and claws soon convinced them to keep their distance! By the time my kittens were a month old, they were already eagerly exploring their surroundings. At first they copied me and hissed and spat at the people who approached them. But kittens will be kittens—and soon they became completely tame.

When my kittens were several months old, some of them were suddenly given away. I cried piteously as I searched

high and low for them. The people in the house were very surprised, as they had never heard me cry so. Eventually, I would have taught my kittens to be independent and sent them away from me—but how it hurt to have them so cruelly taken away!

Tombo was my firstborn of the two kittens who remained. He is maddeningly slow and easygoing. Just look at the pictures of him on pages 53 to 60—see how often you can catch Tombo sleeping? Sometimes I think that if a mouse were to pass right under his nose, that mouse would have nothing to fear! But I don't mean to imply that Tombo does nothing at all—in fact, it's his job to chase away any stray cats who wander into our territory! He's very good at it, too, and is usually covered with battle scars. Tombo goes outdoors so often that he is always dirty. I am embarrassed to say that he more often resembles a homeless stray than a son of mine! Tombo loves to groom me and his brother, Taro. I enjoy having my fur licked, so I sit quietly, purring in contentment. Taro, on the other hand, hates it. More often than not, Tombo's determined attempts to groom Taro end with them fighting.

Taro is the exact opposite of Tombo. He is bright and animated, and loves to catch mice. Taro is very fond of the people who share our house, but flees when strangers approach. More than anything else, Taro loves to eat. When Tombo and I are not careful, Taro will even eat our food as well as his own! You can see Taro on pages 27, and 48 to 52. And, in case you are interested, you can find pictures of me on pages 1, 3, 4, 6, 7, 14, 15, 17, 30, 31, 32, 39 and 41.

Here, then, is our family of cats—the slow but steady bodyguard Tombo, the nimble mouse-catcher Taro, and that confirmed people-hater, me! Together, *we* rule this house!

Tombo

Taro

Mama

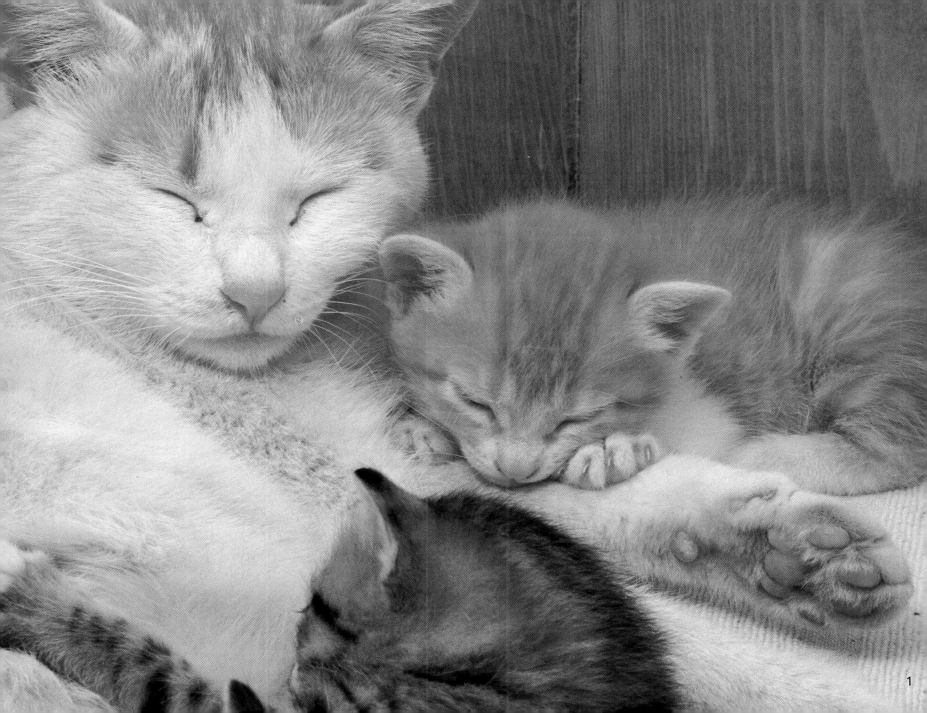

1

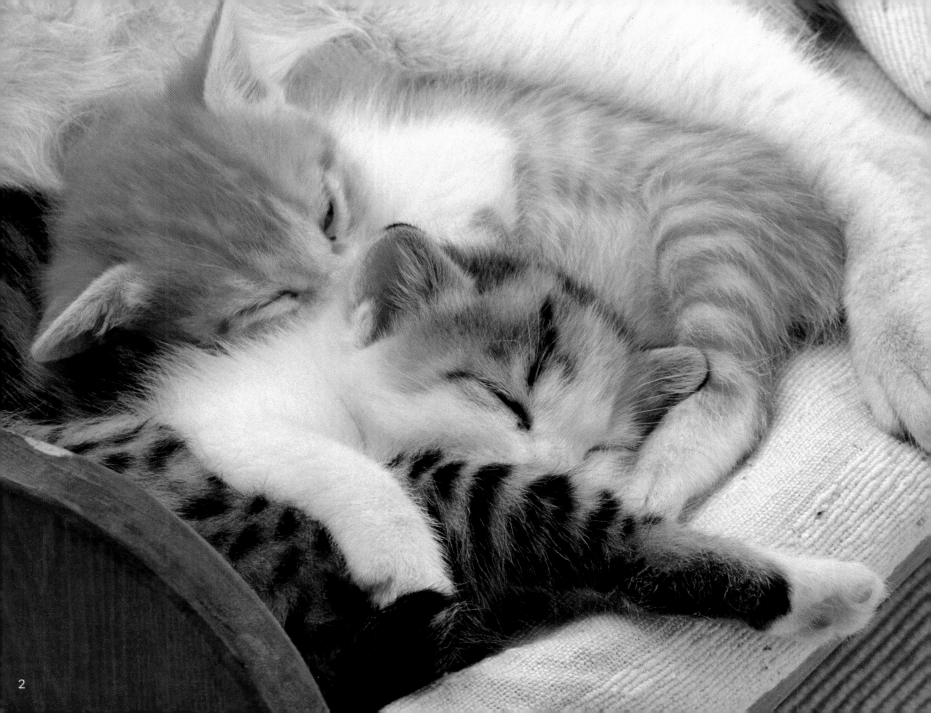

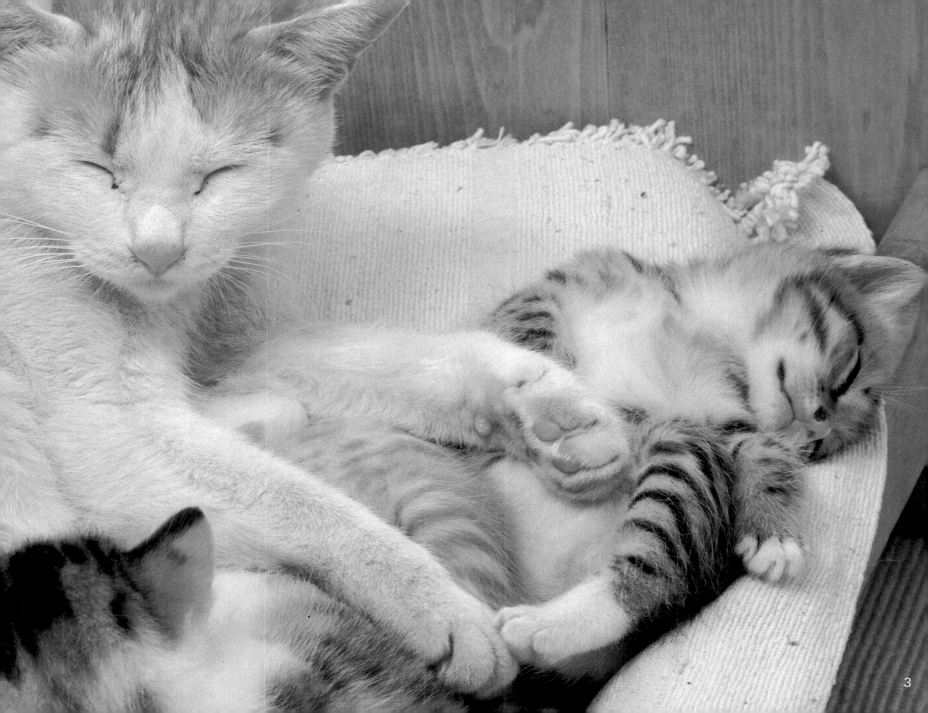

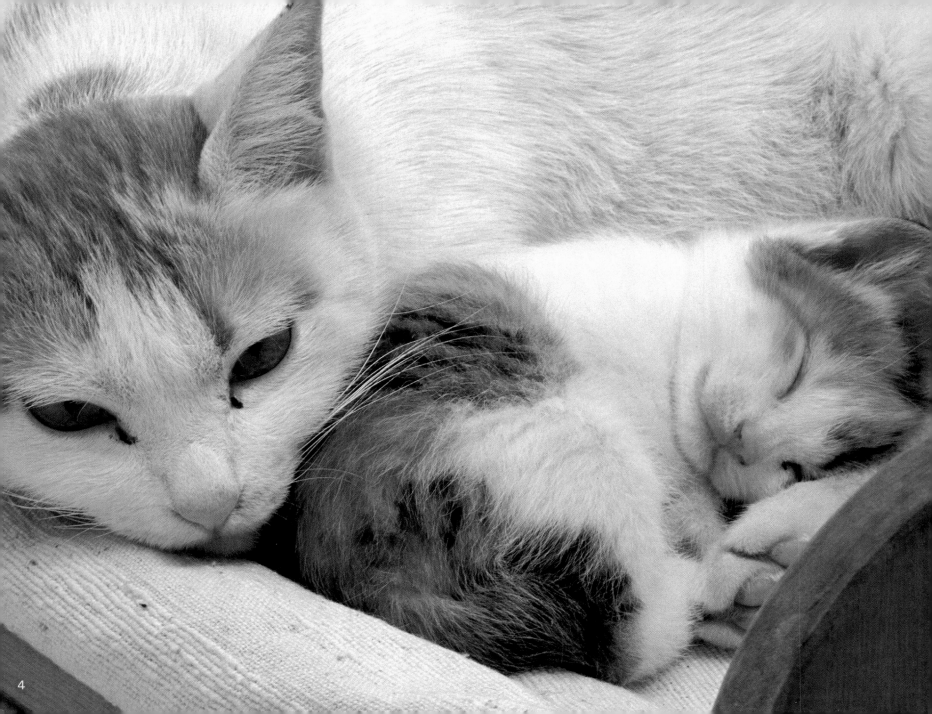

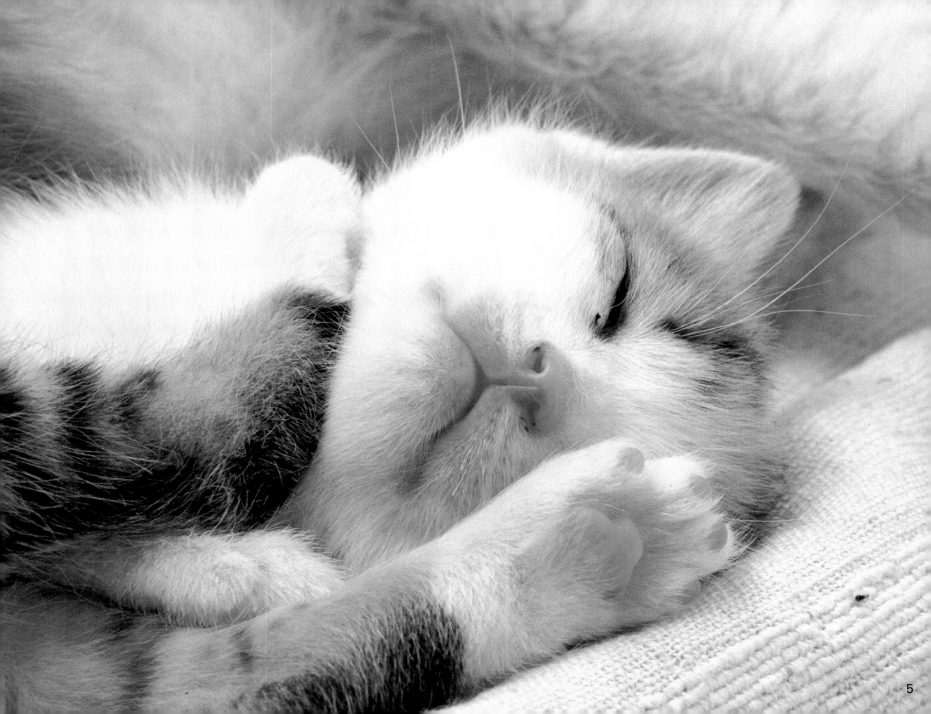

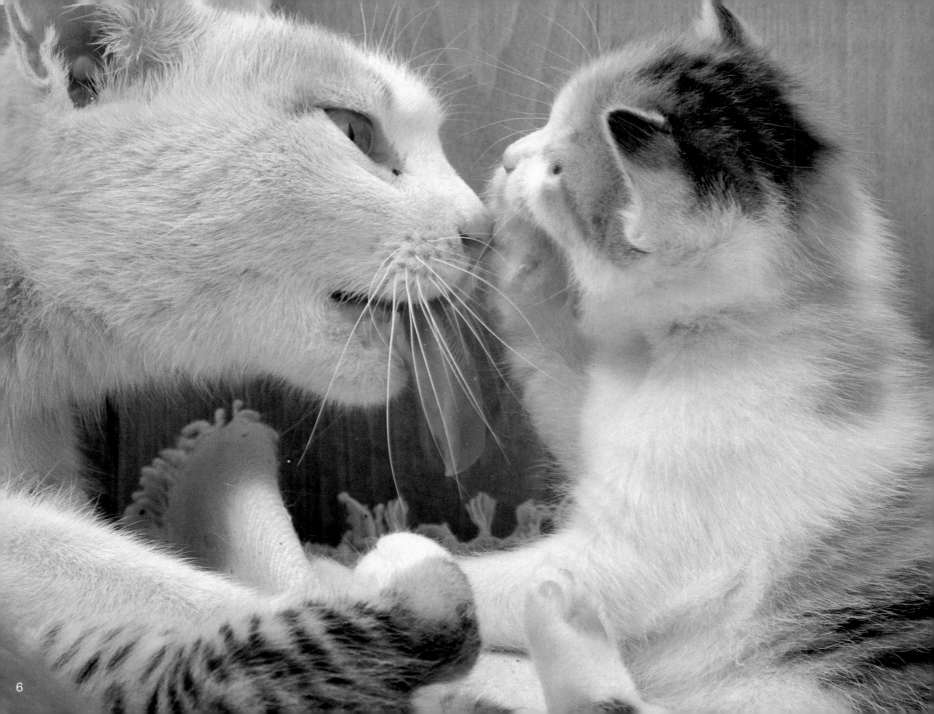

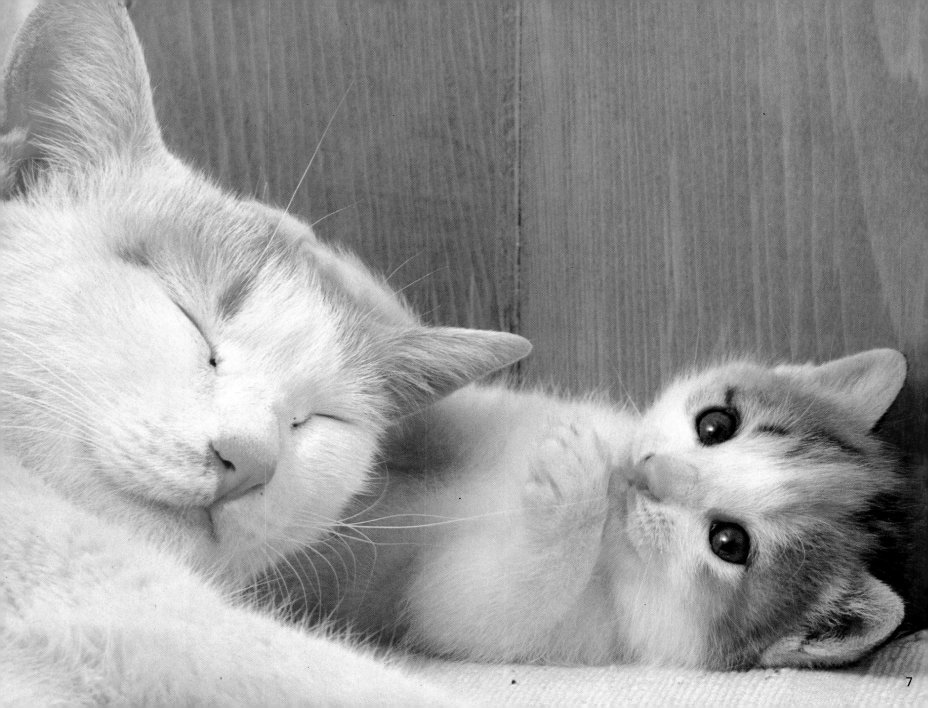

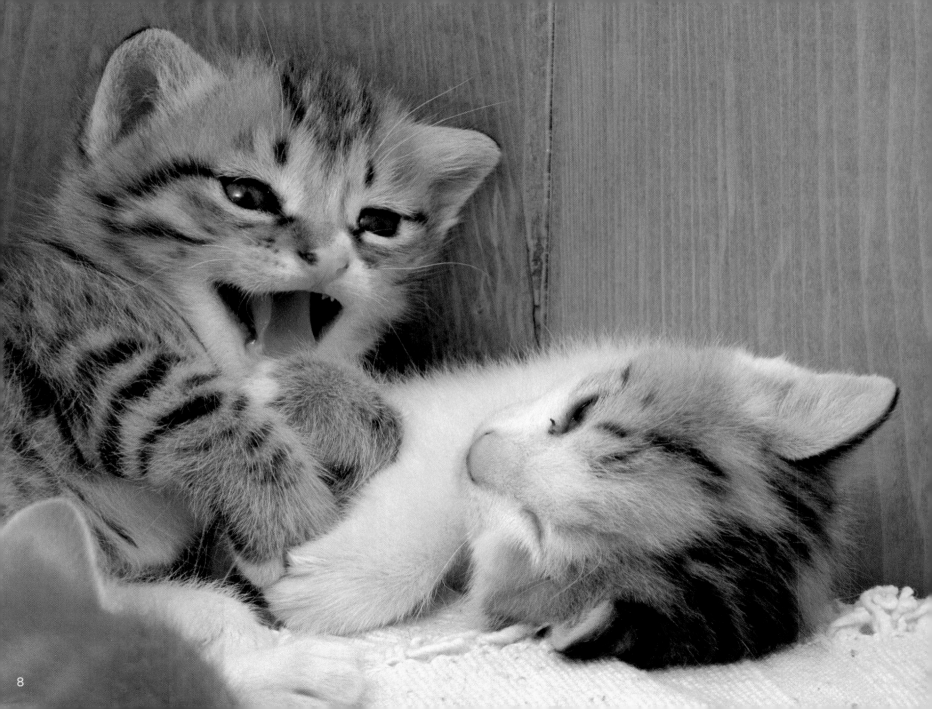

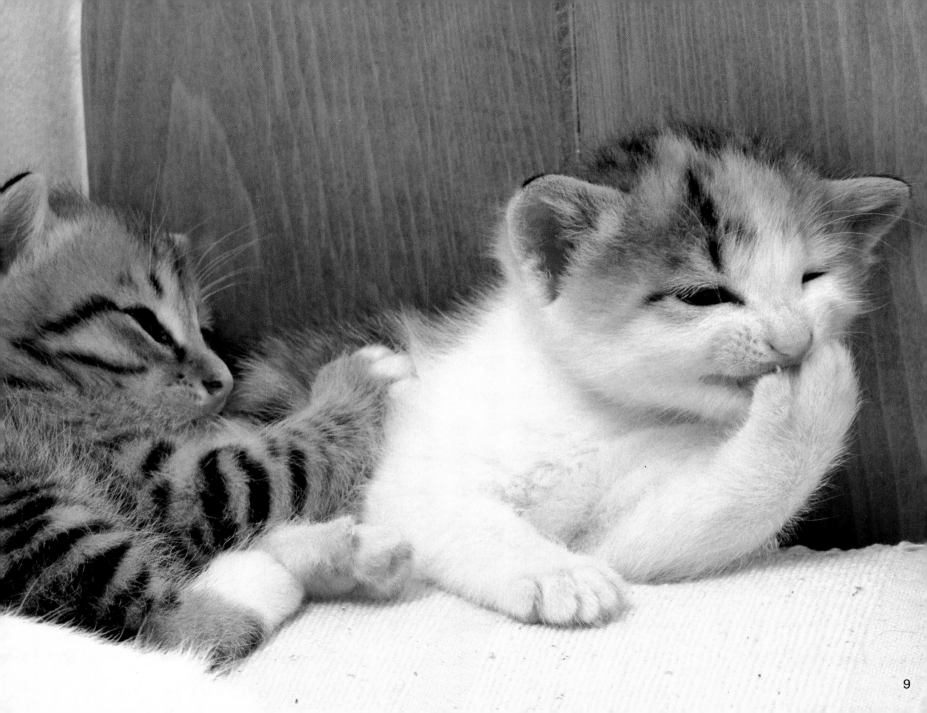

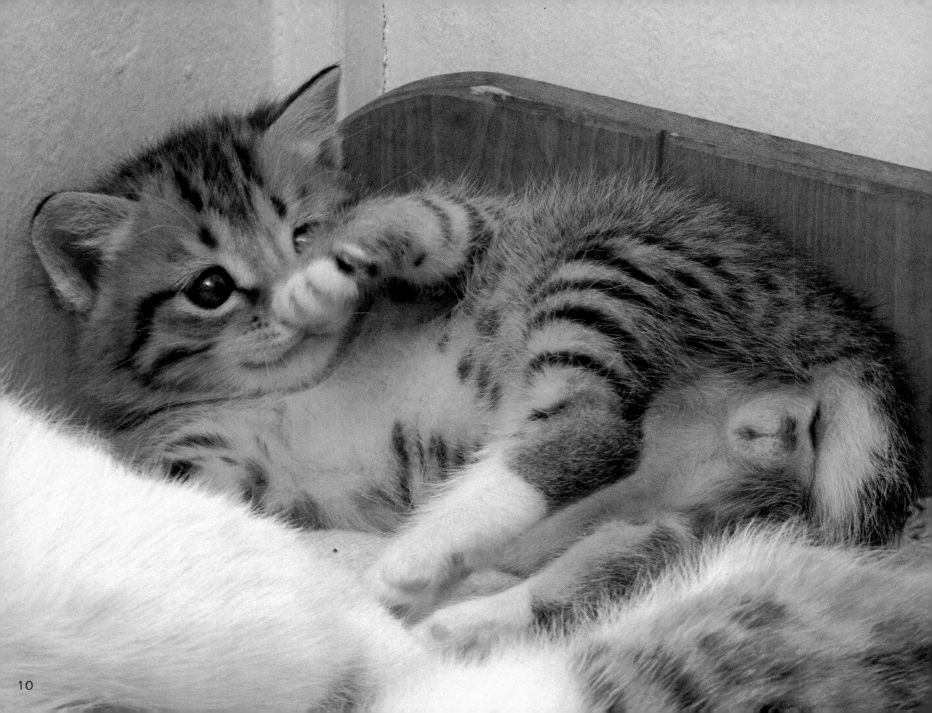

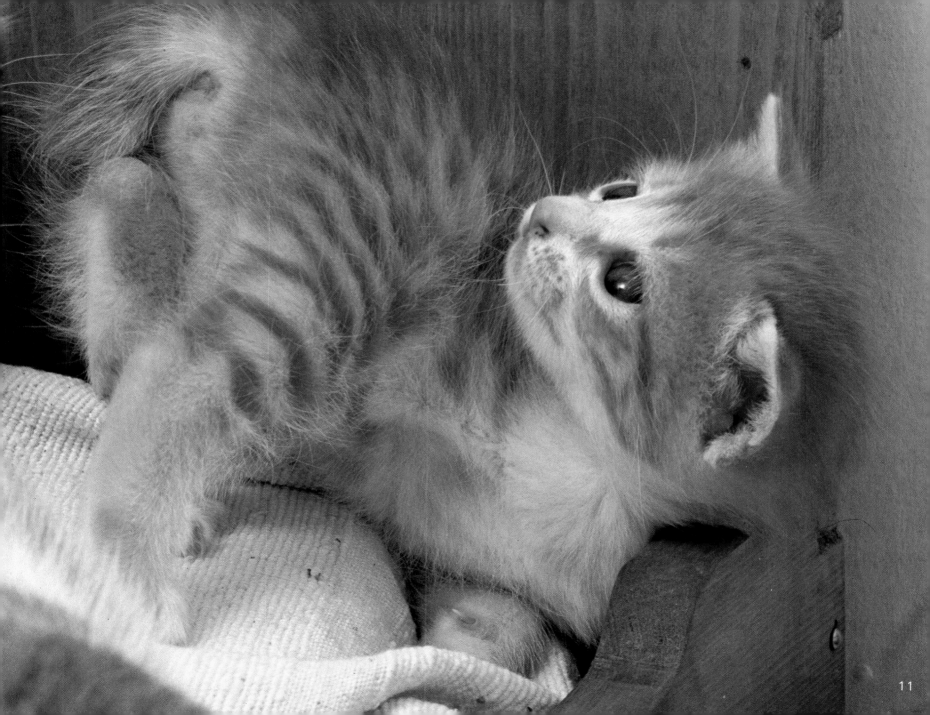

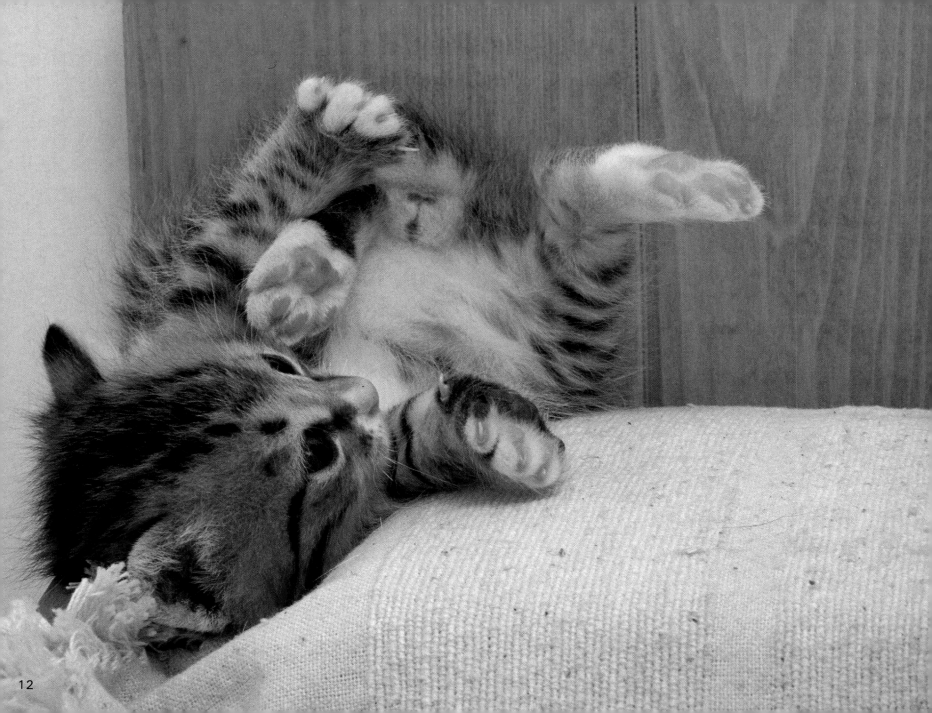

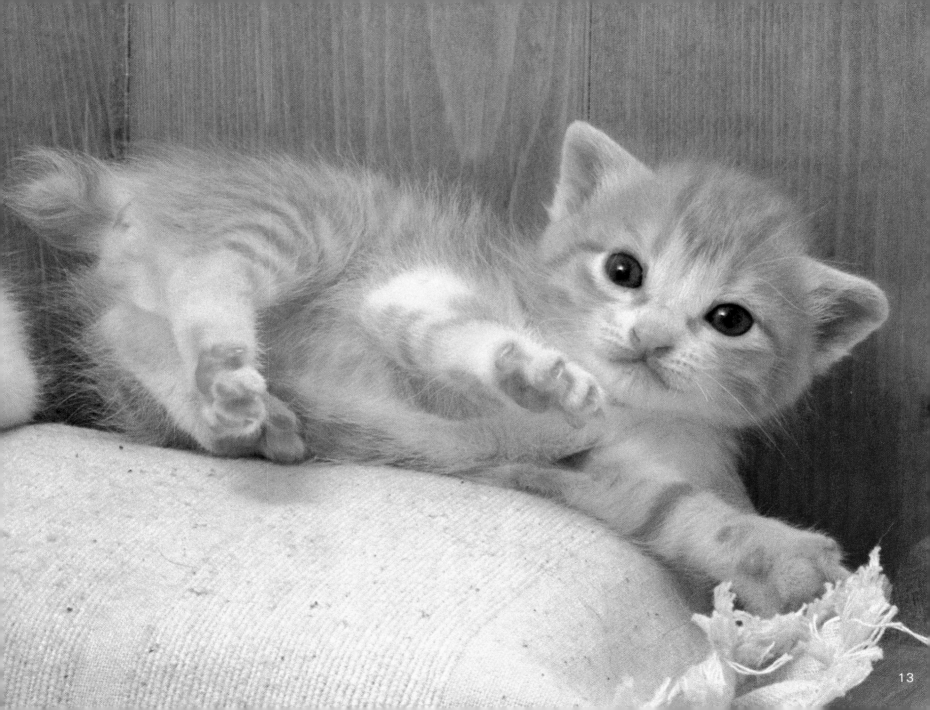

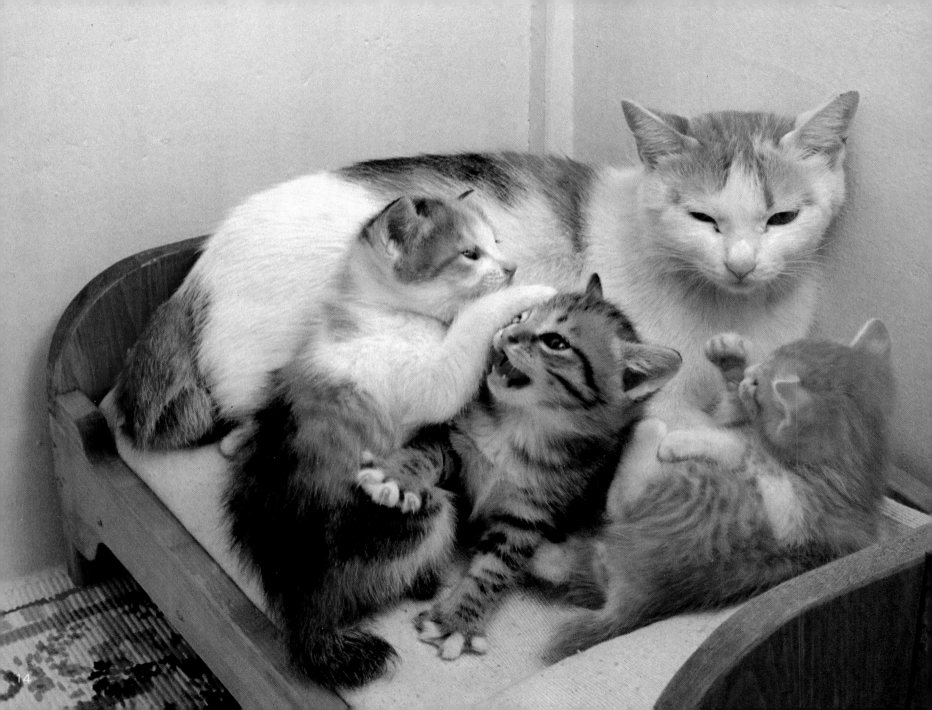

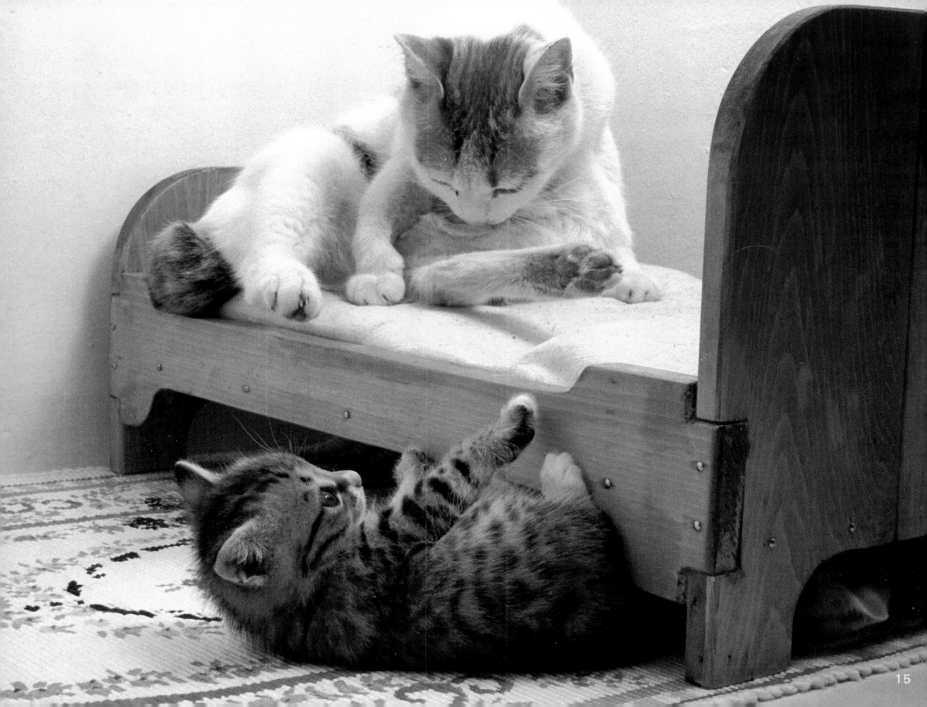

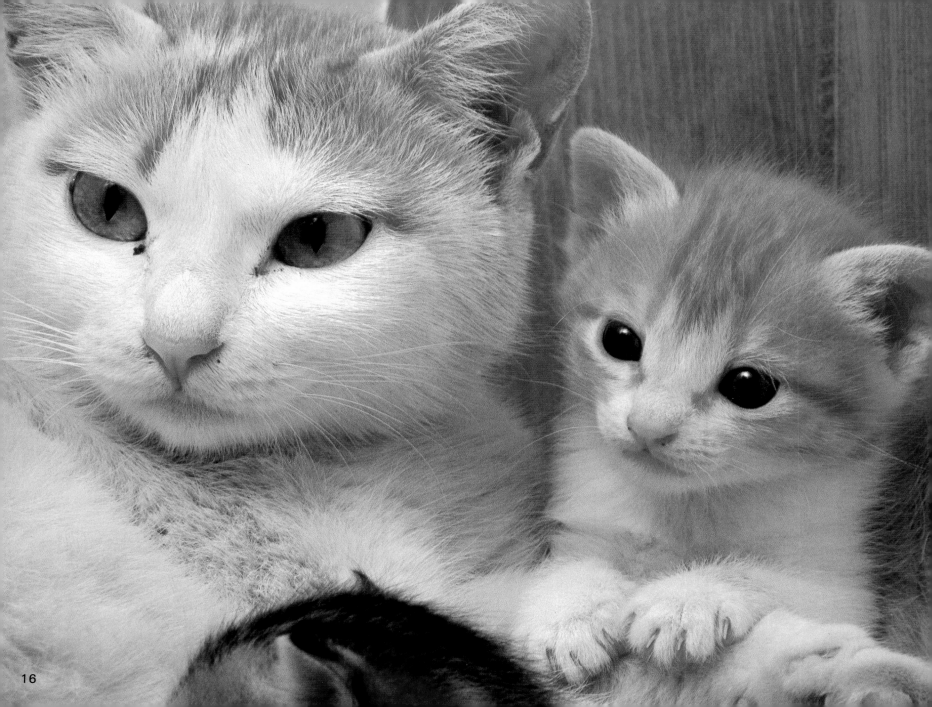

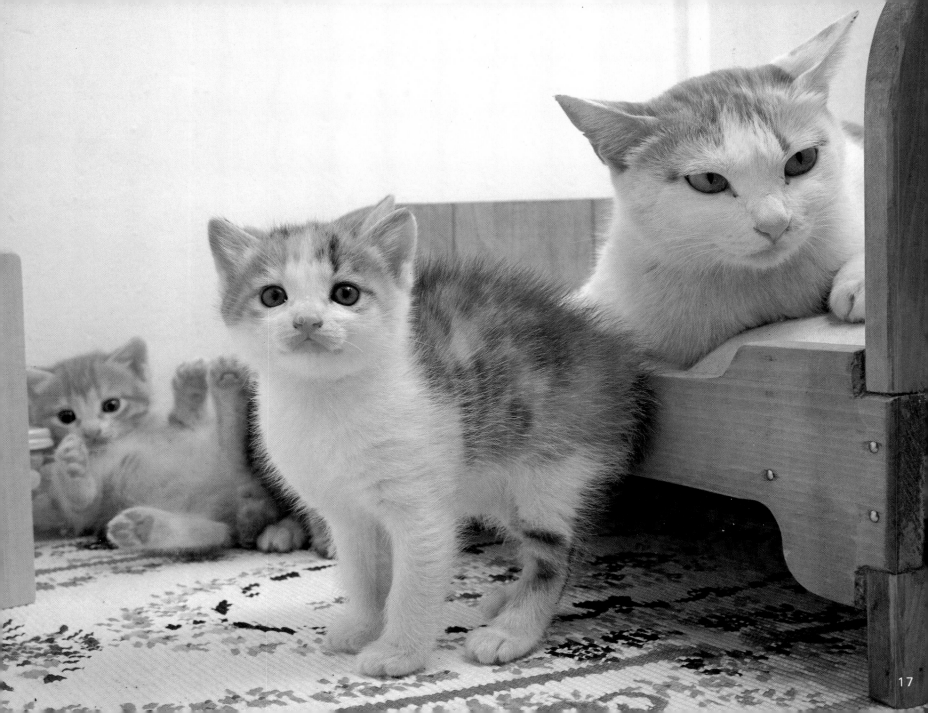

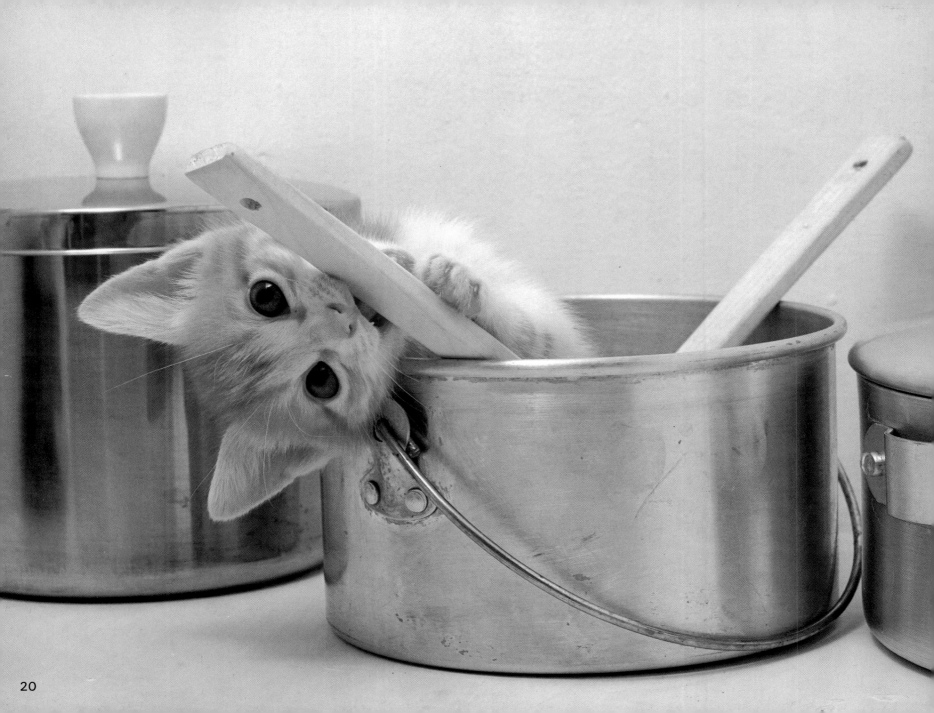

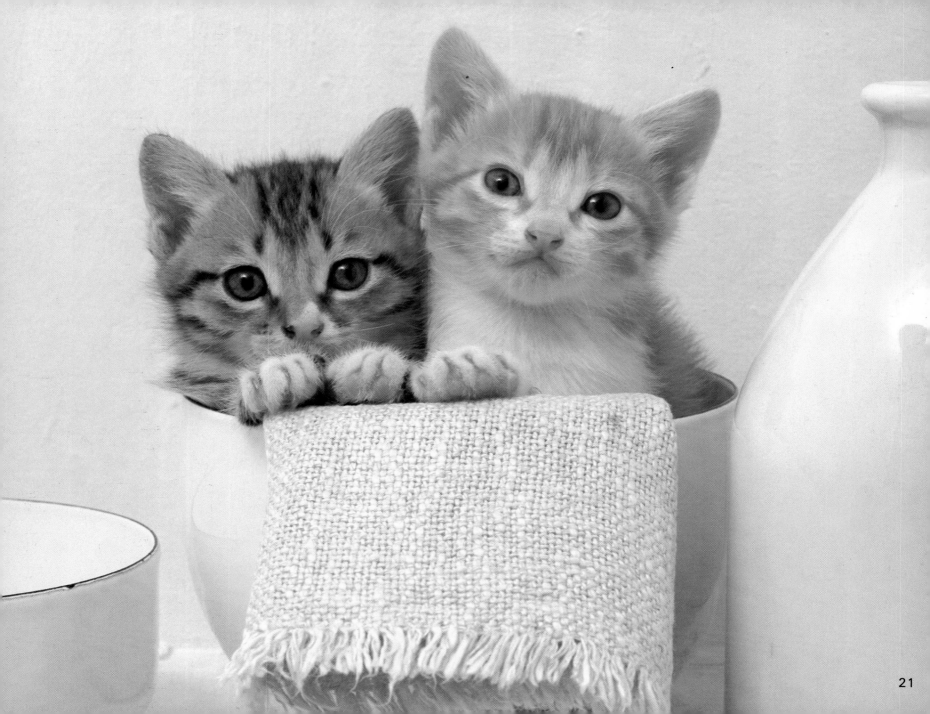

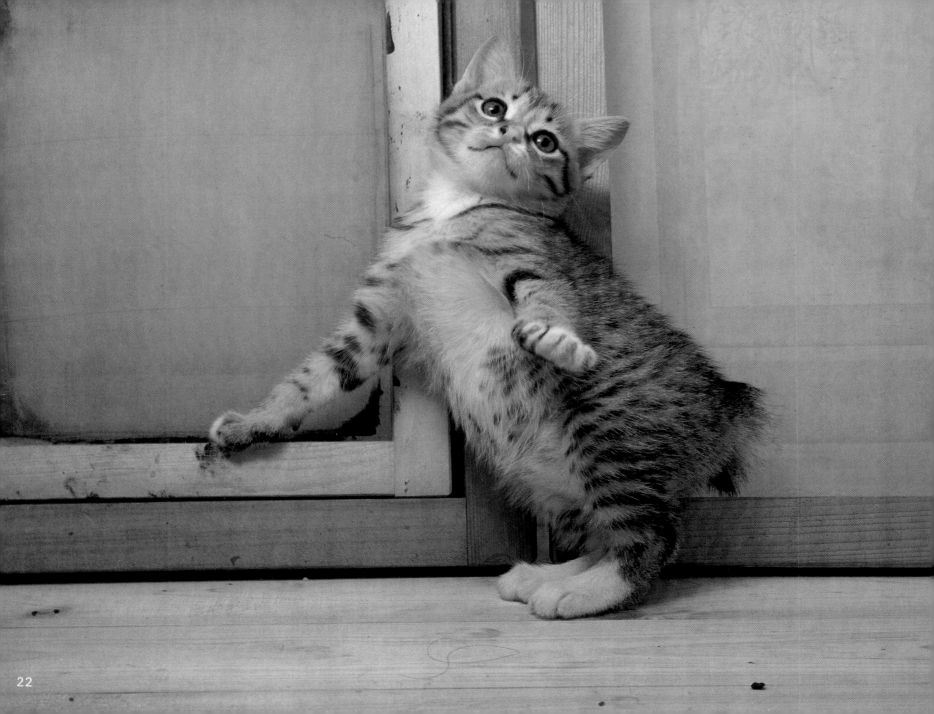

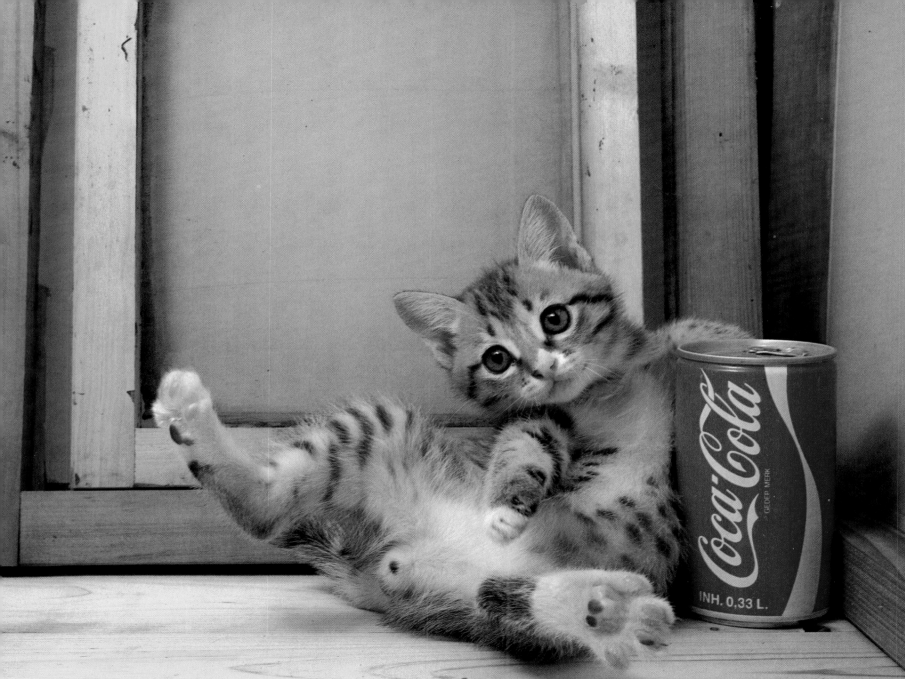

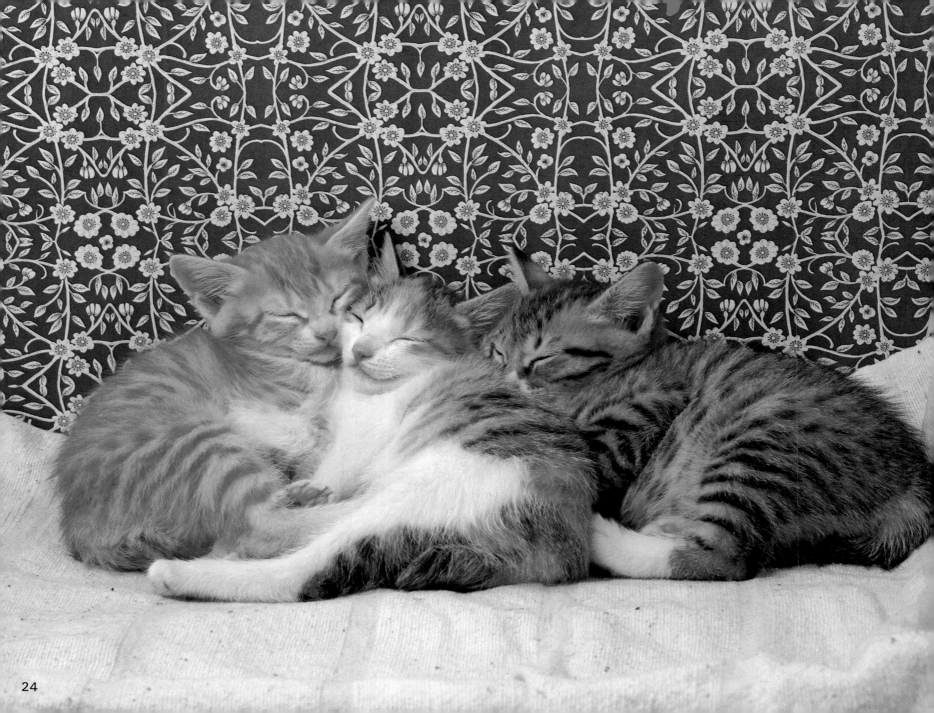

24

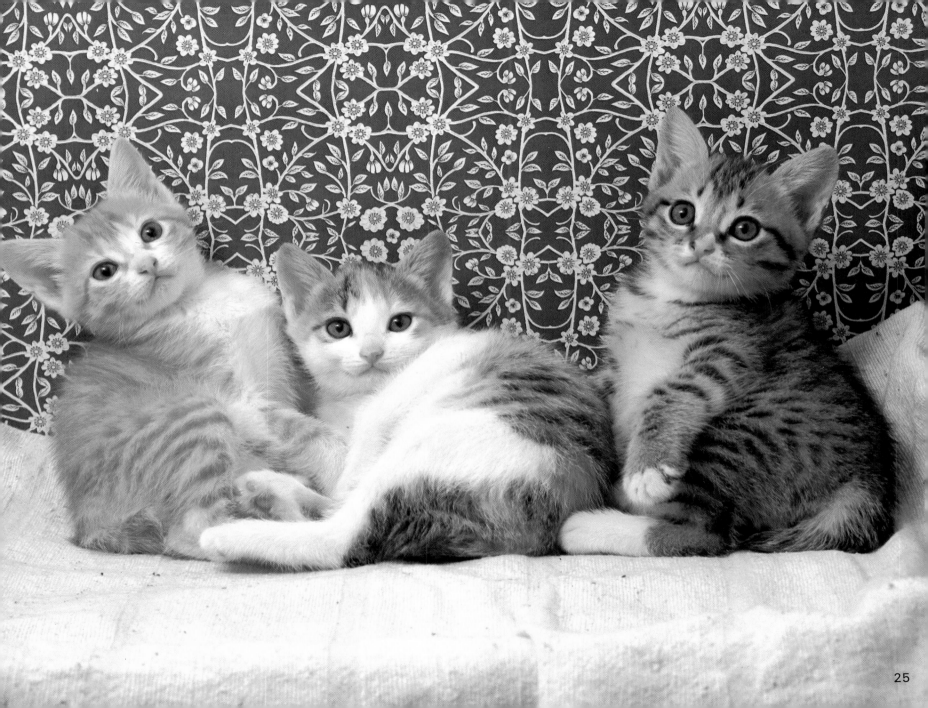

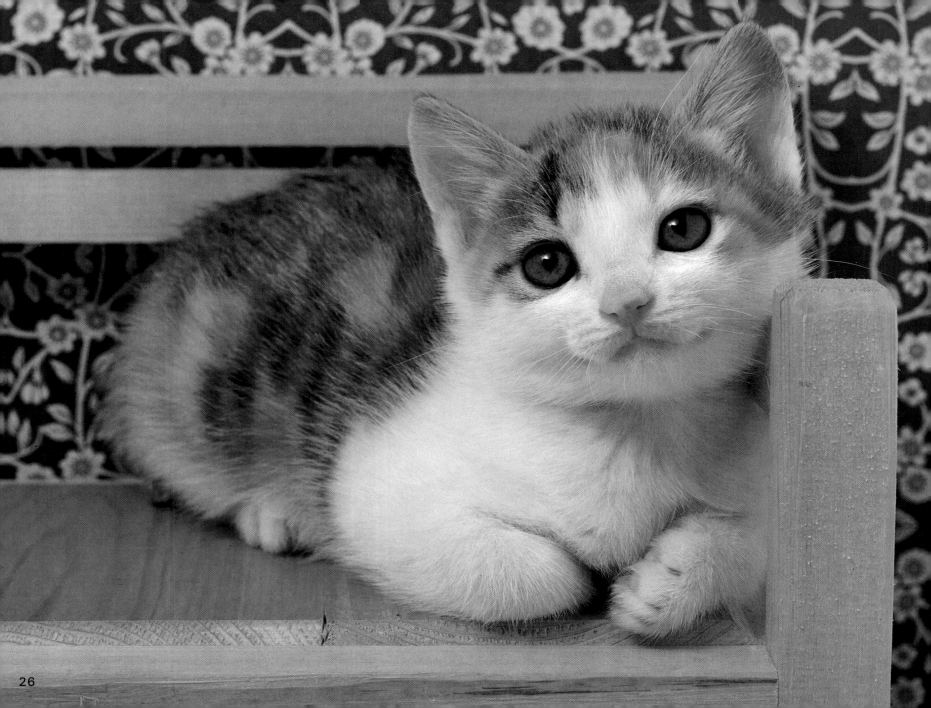

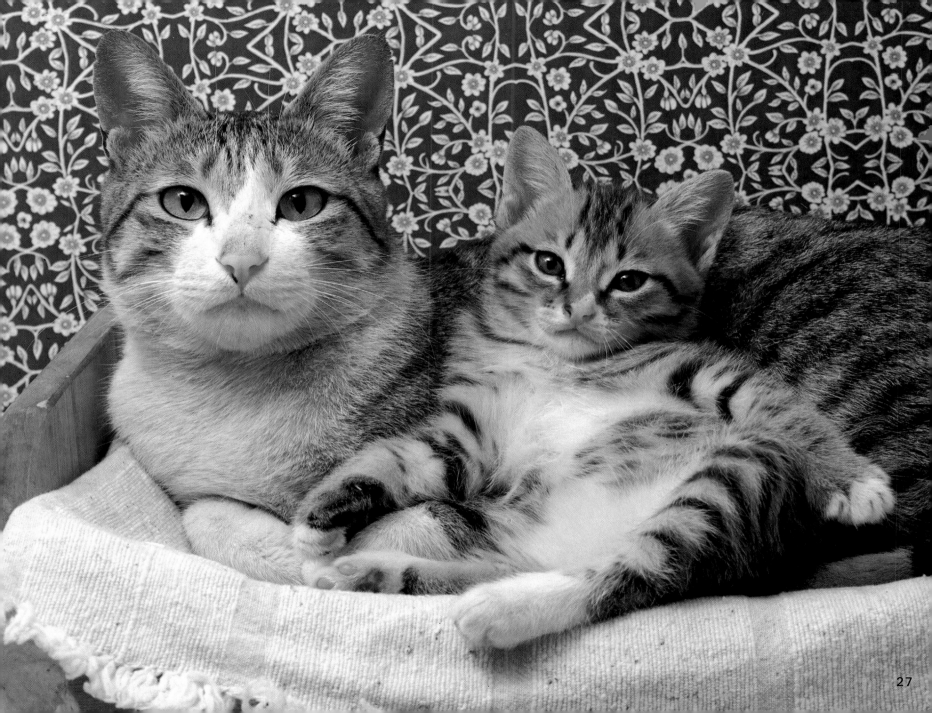

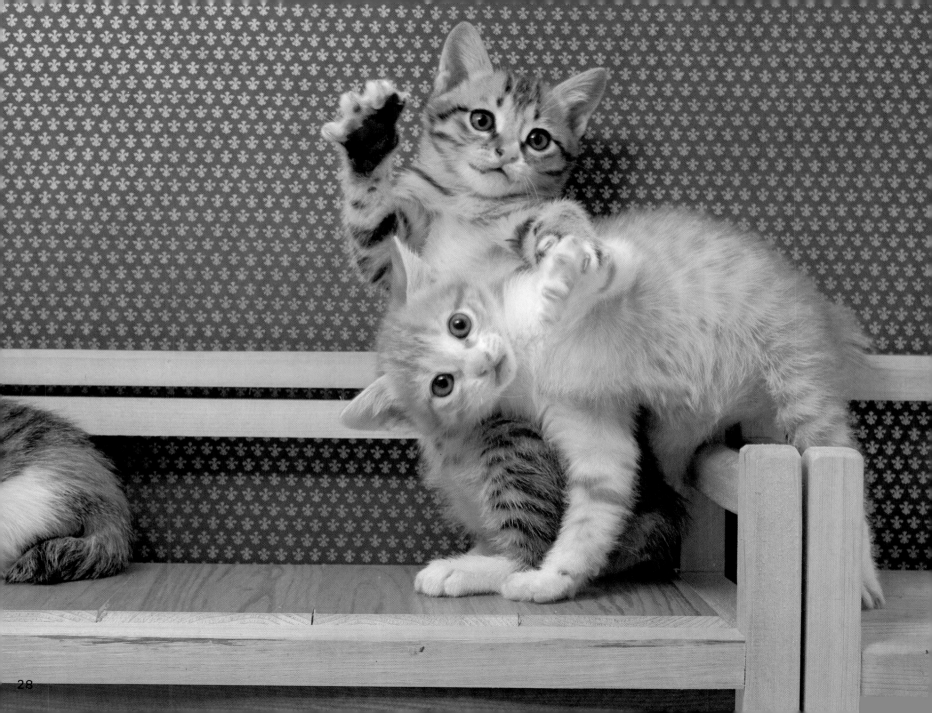

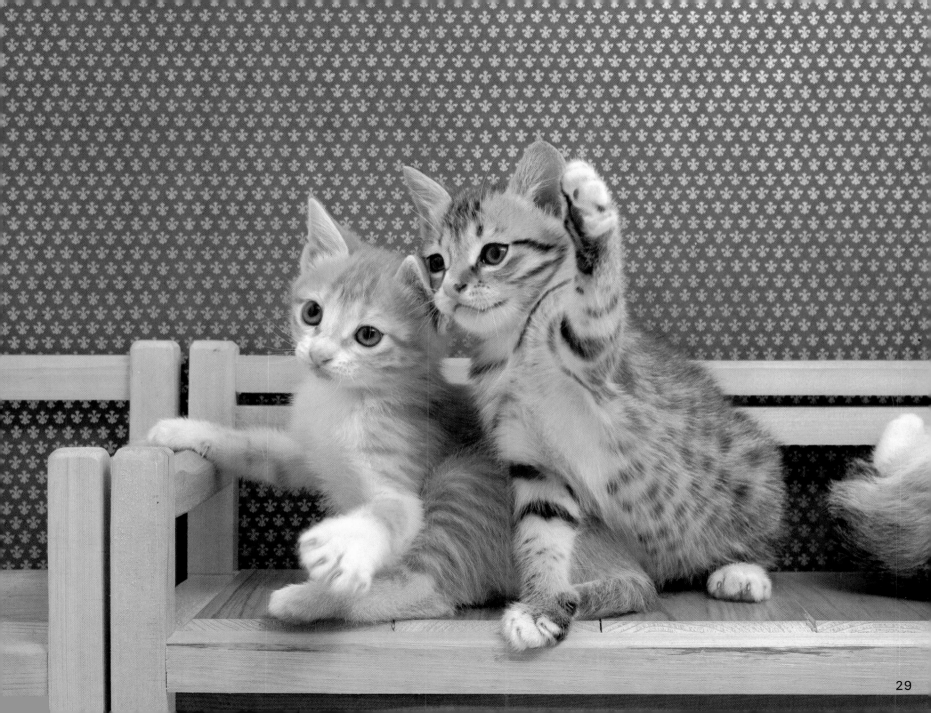

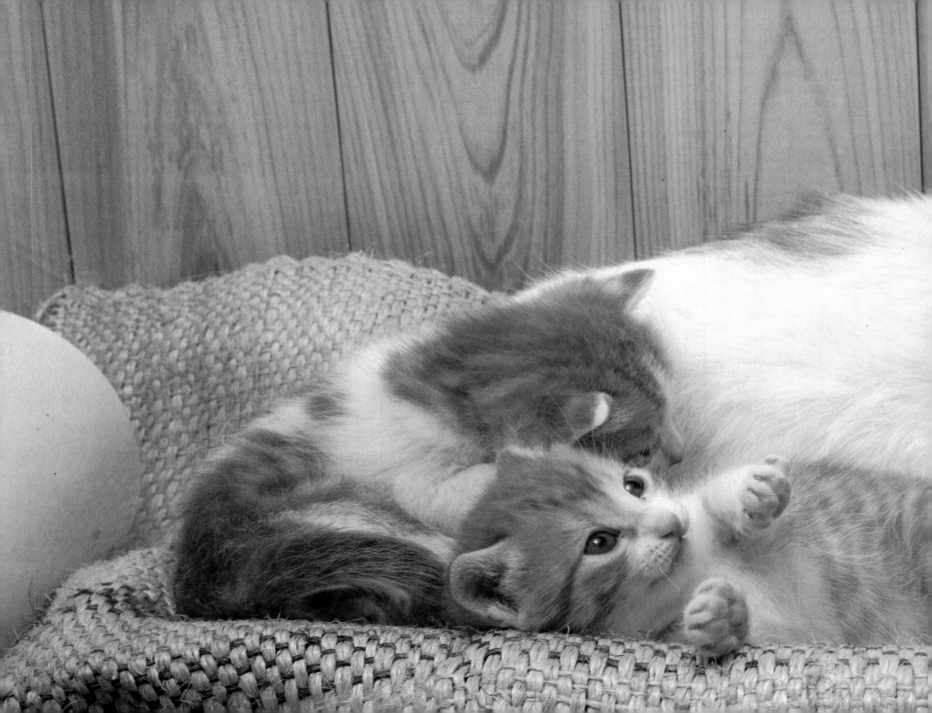

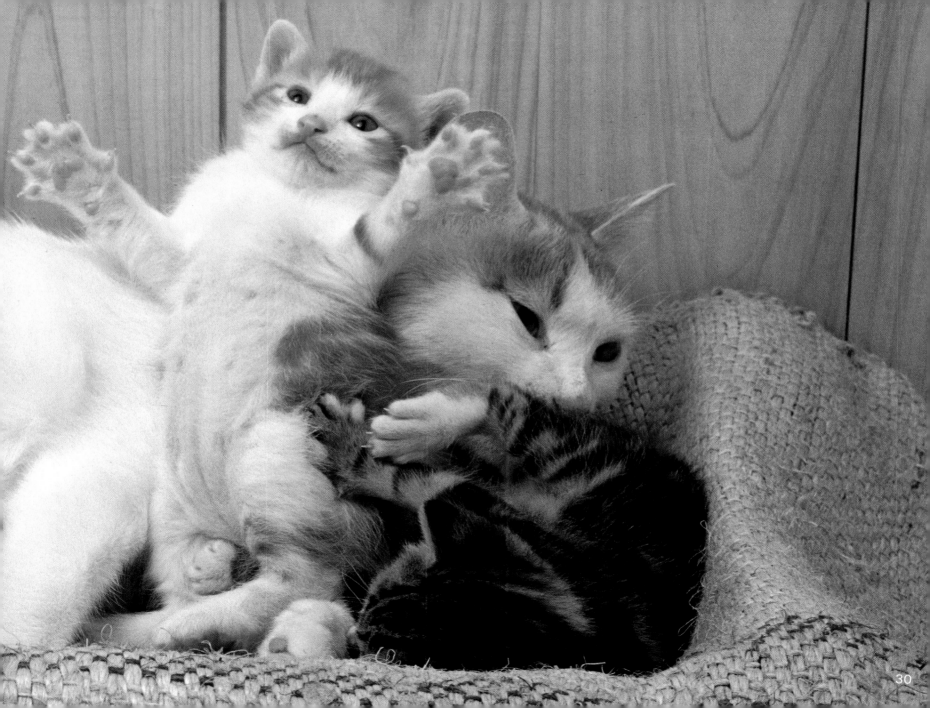

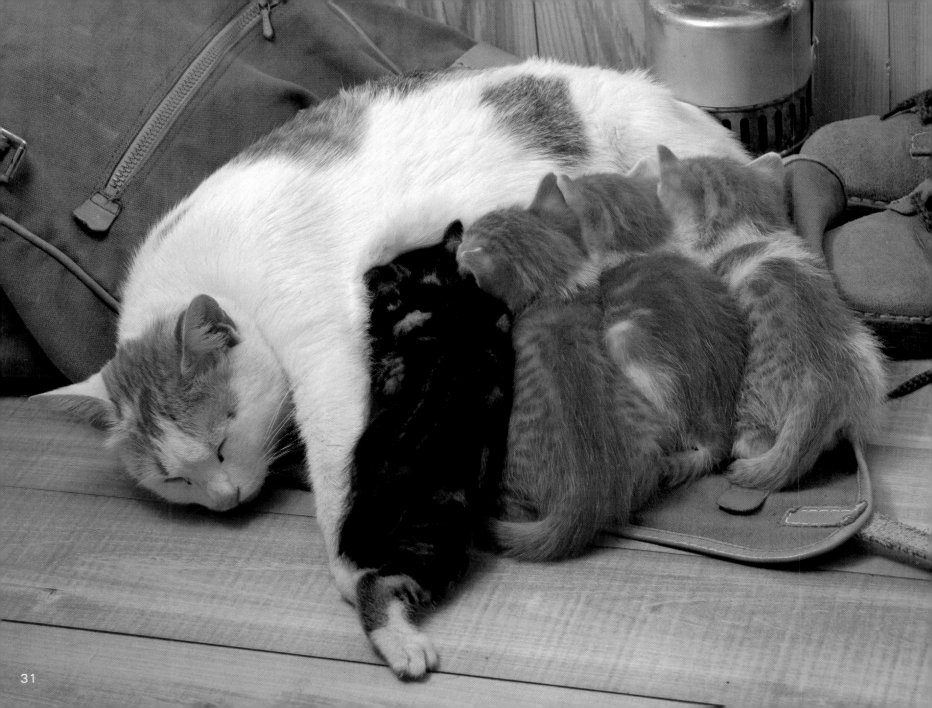

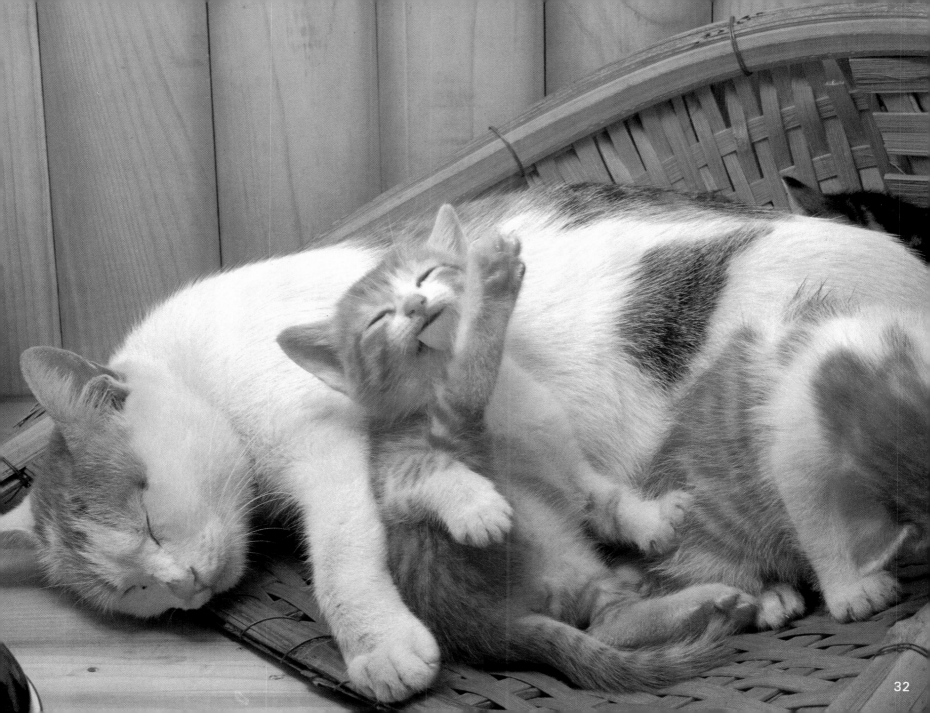

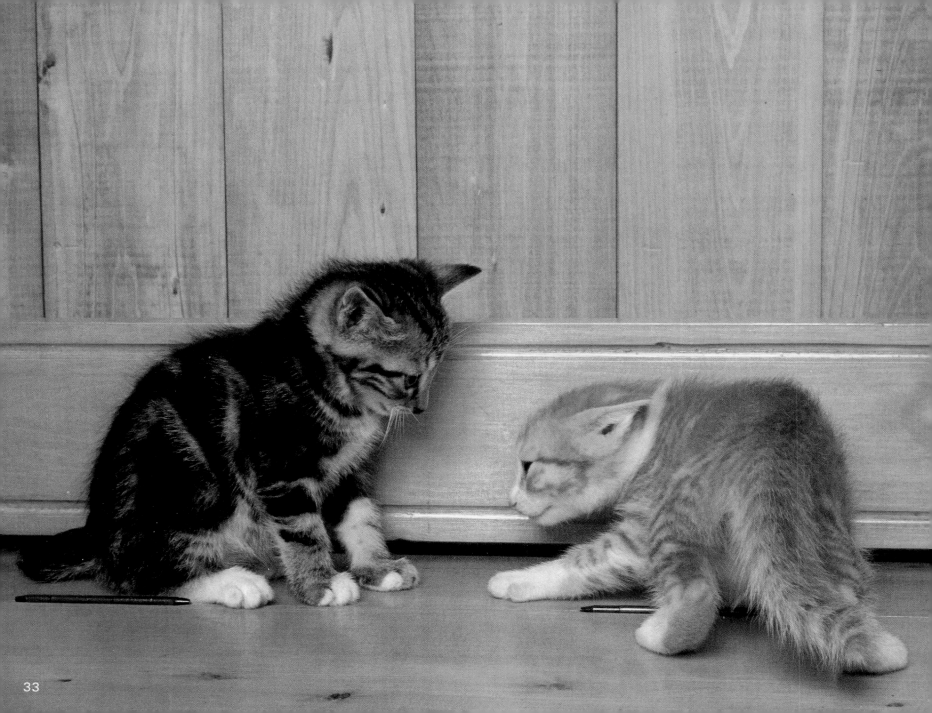

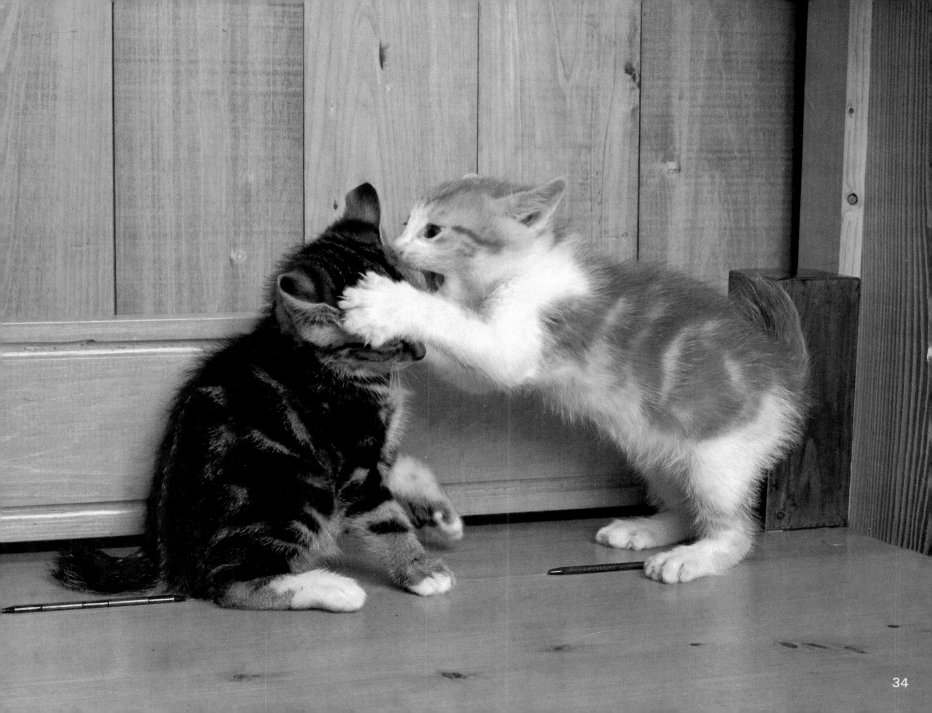

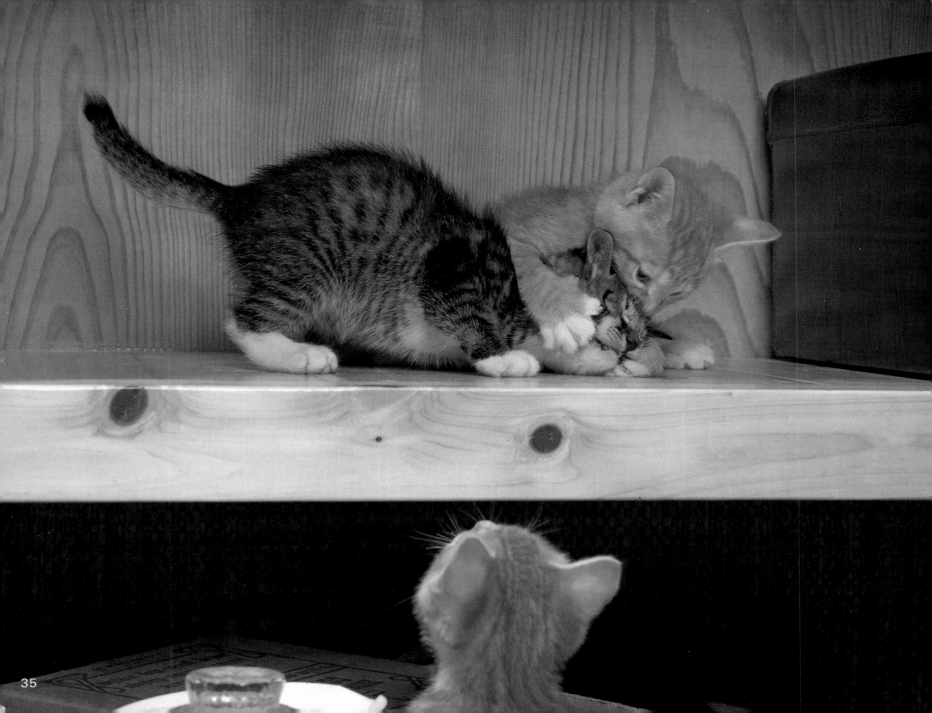

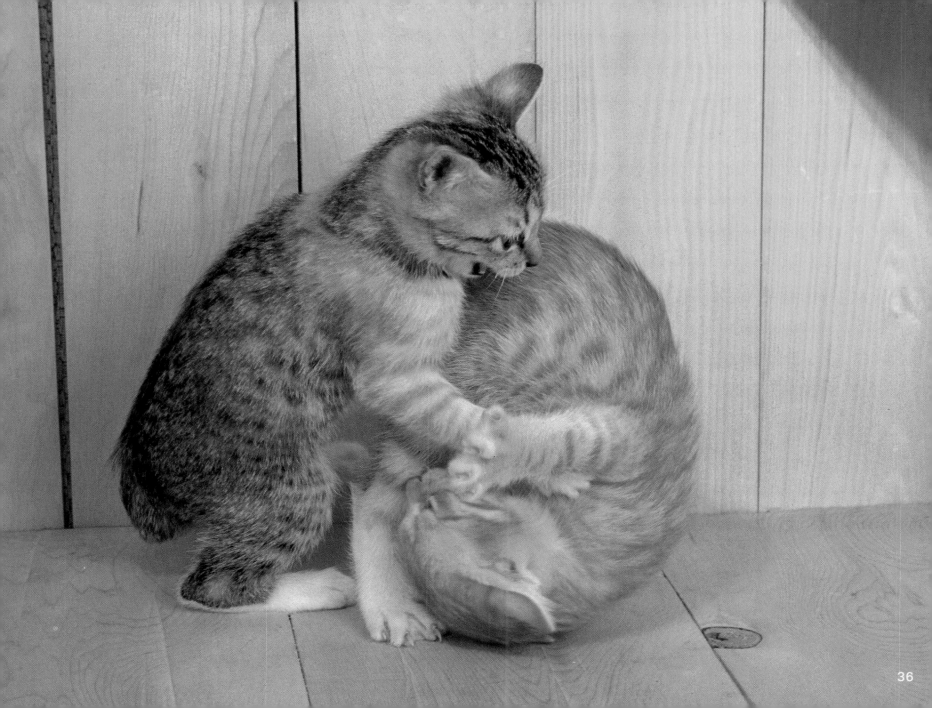

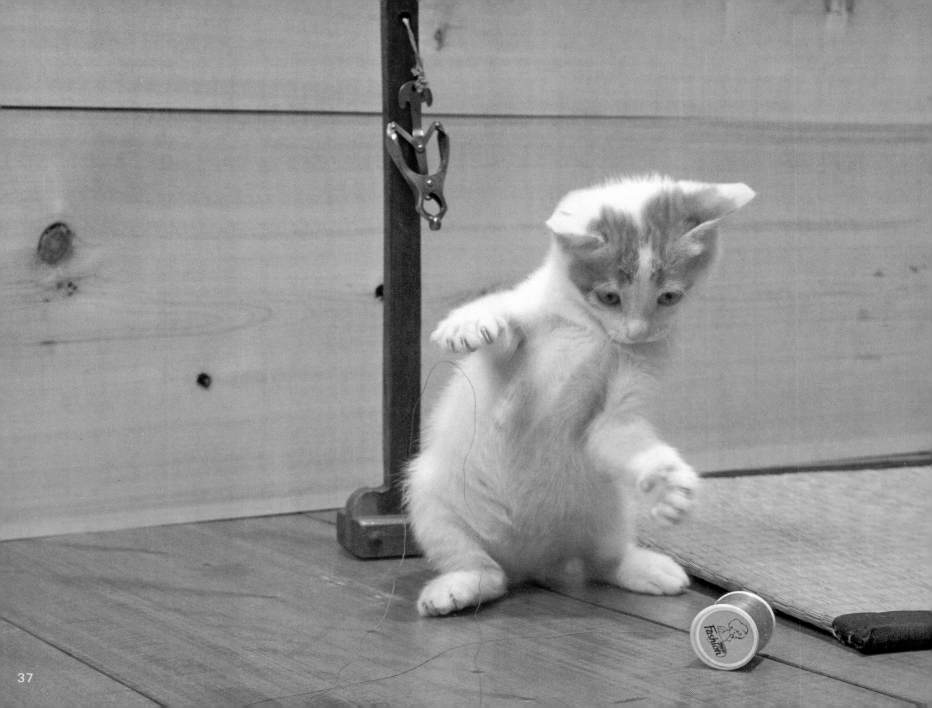

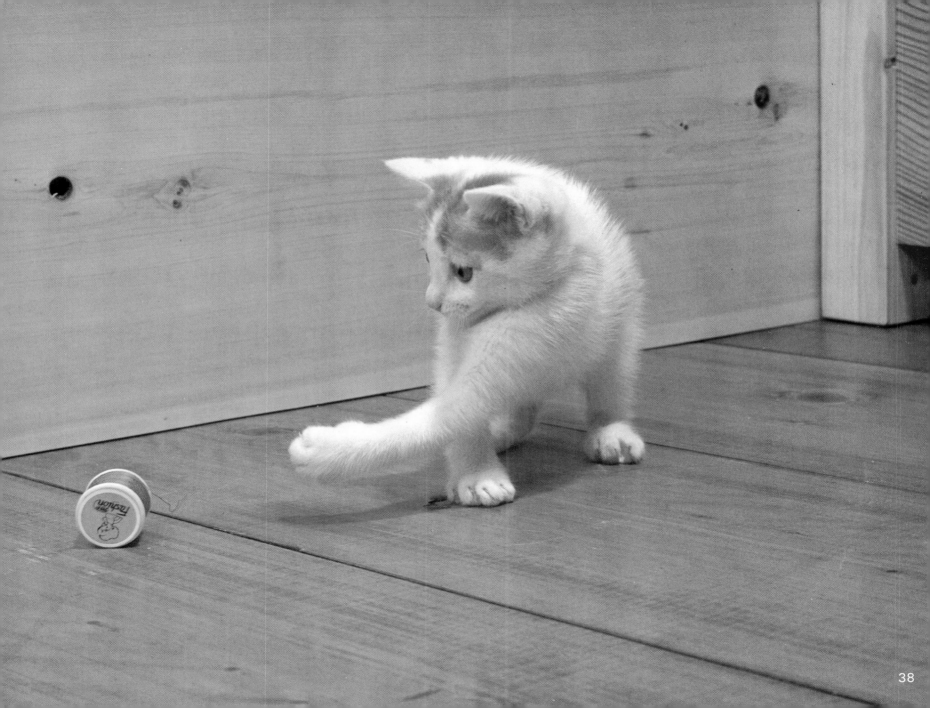

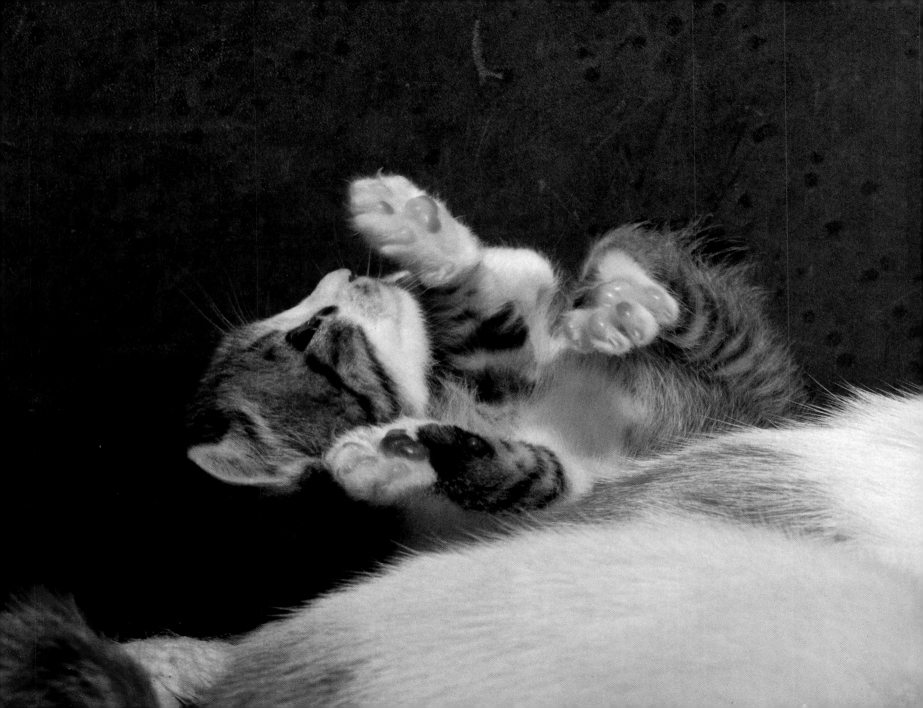

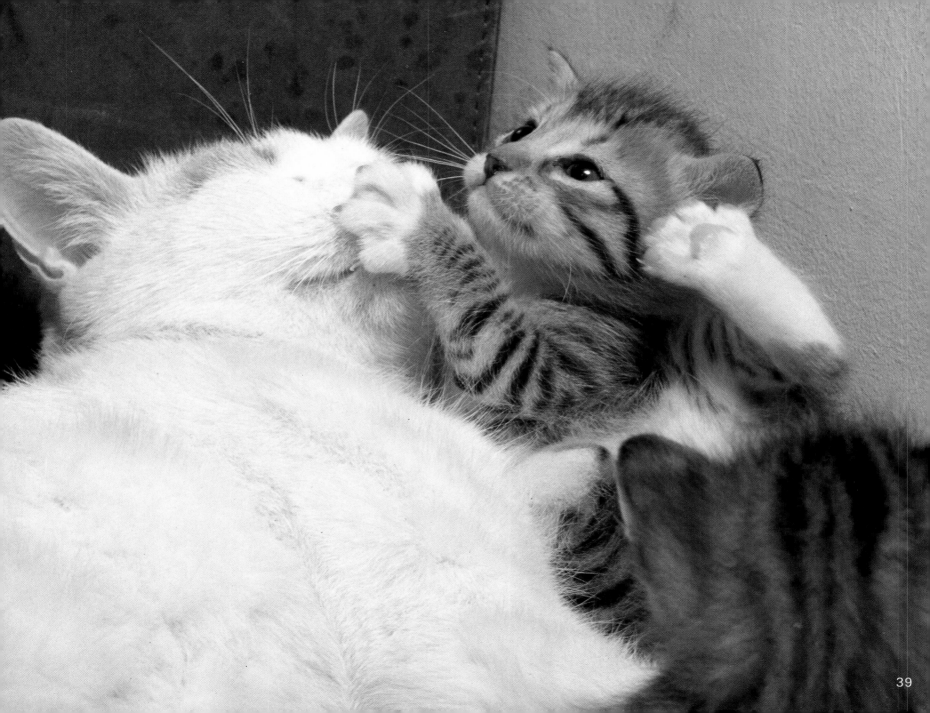

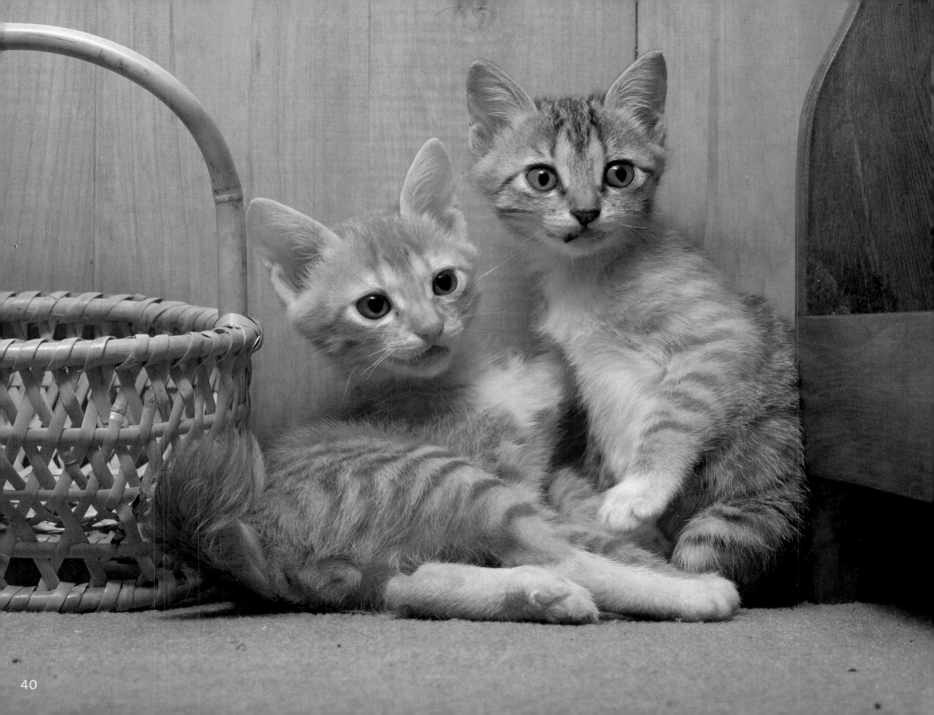

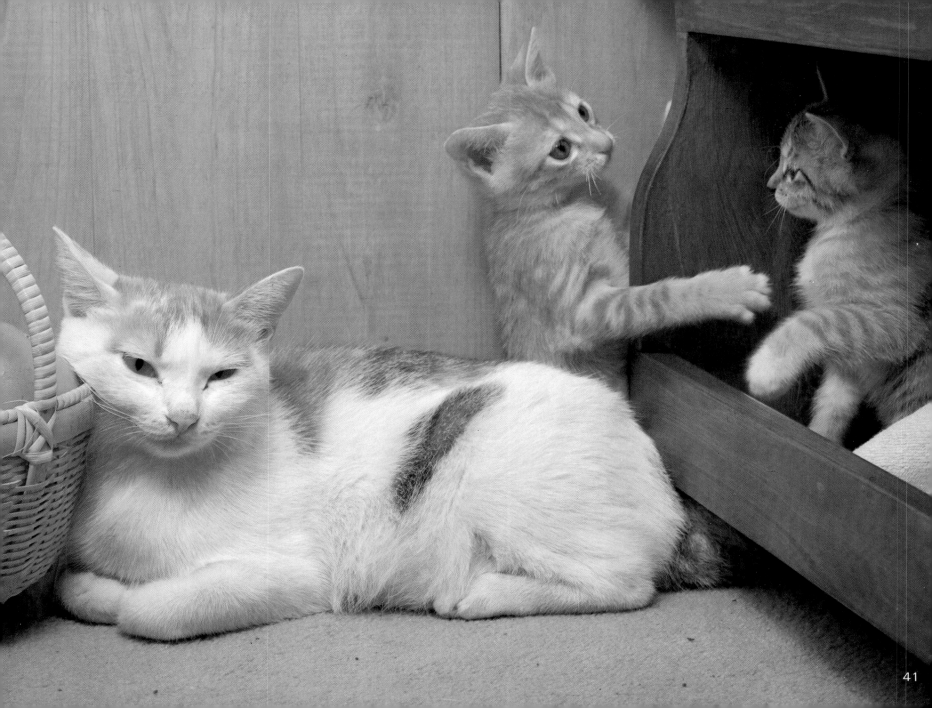

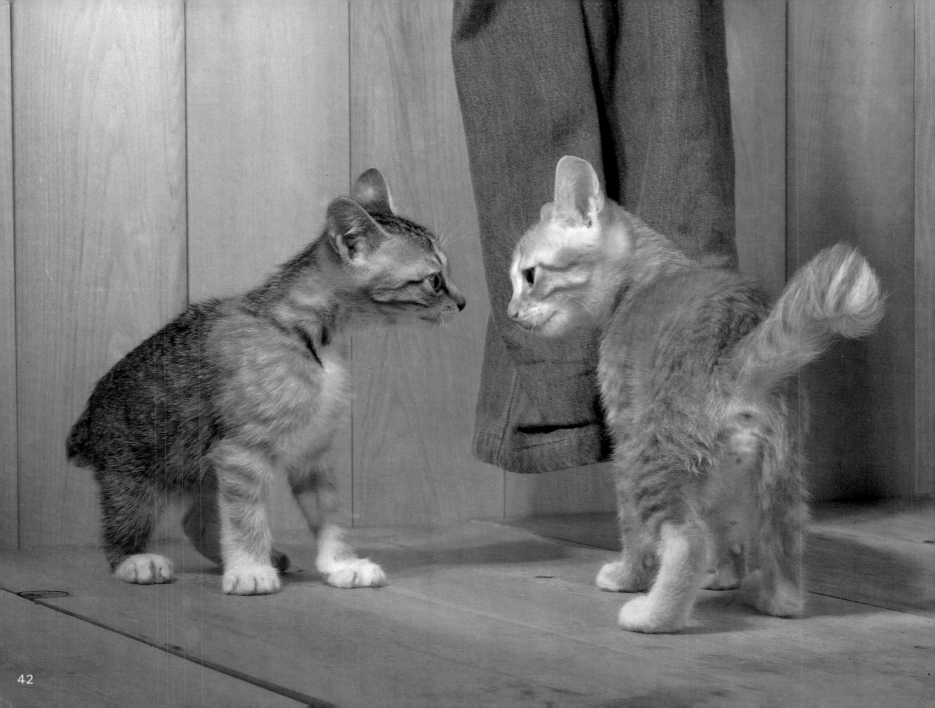

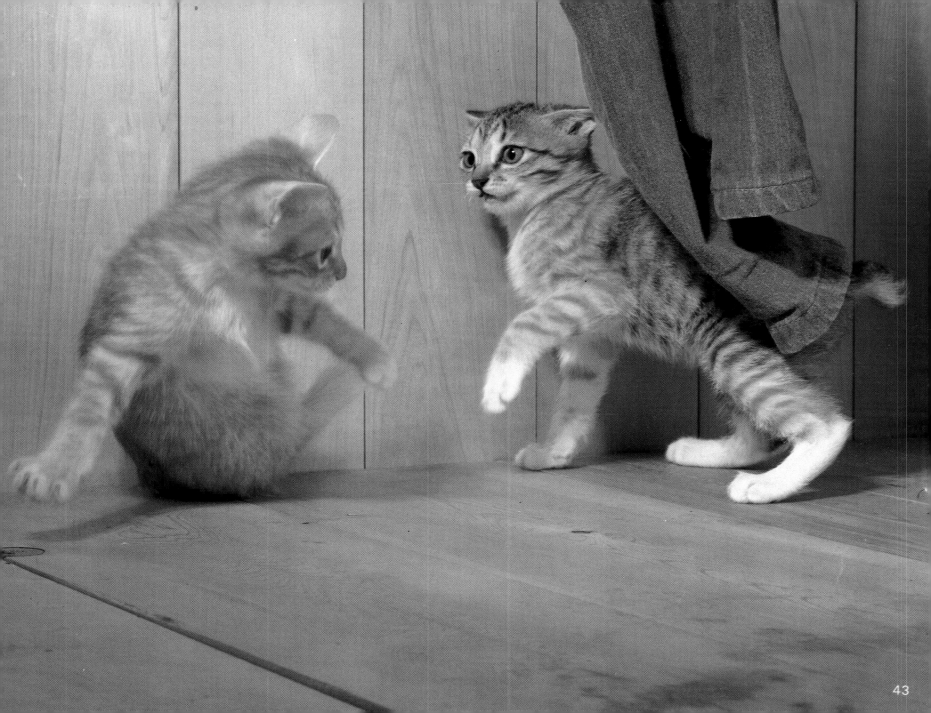

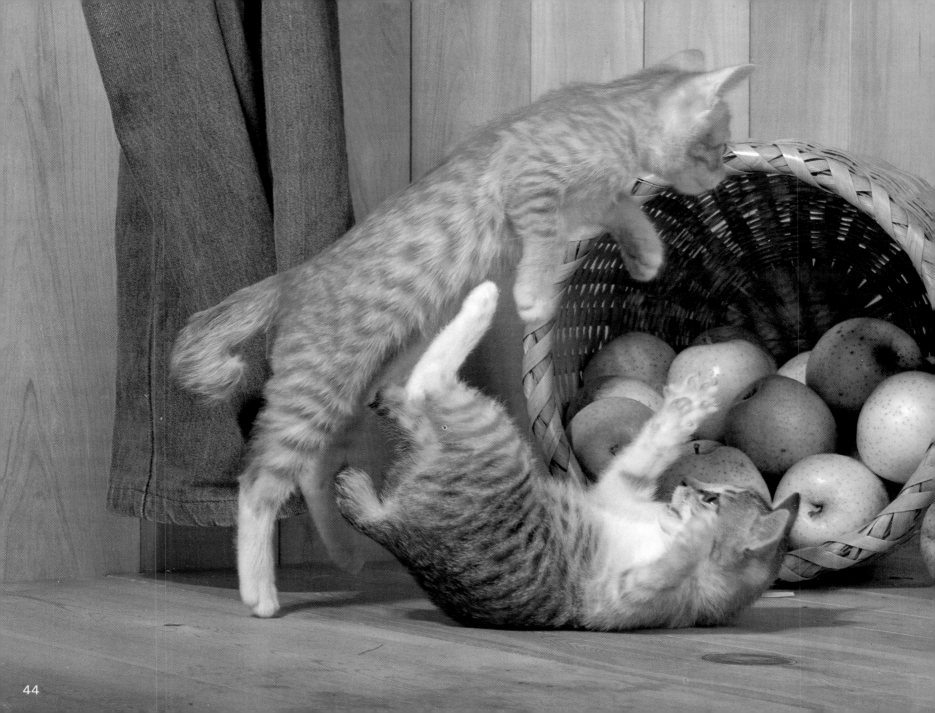

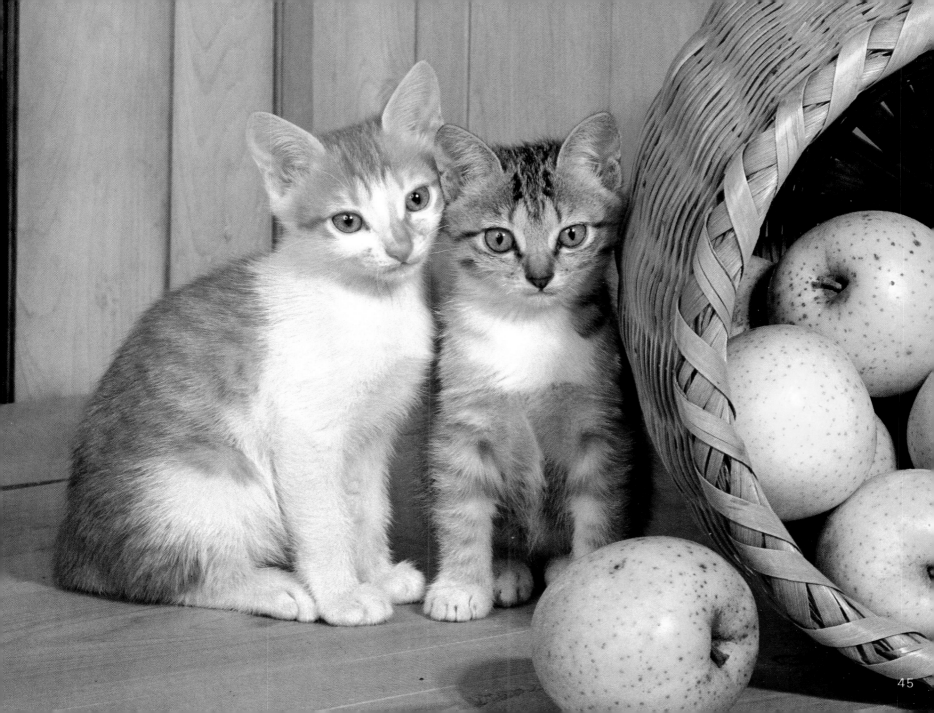

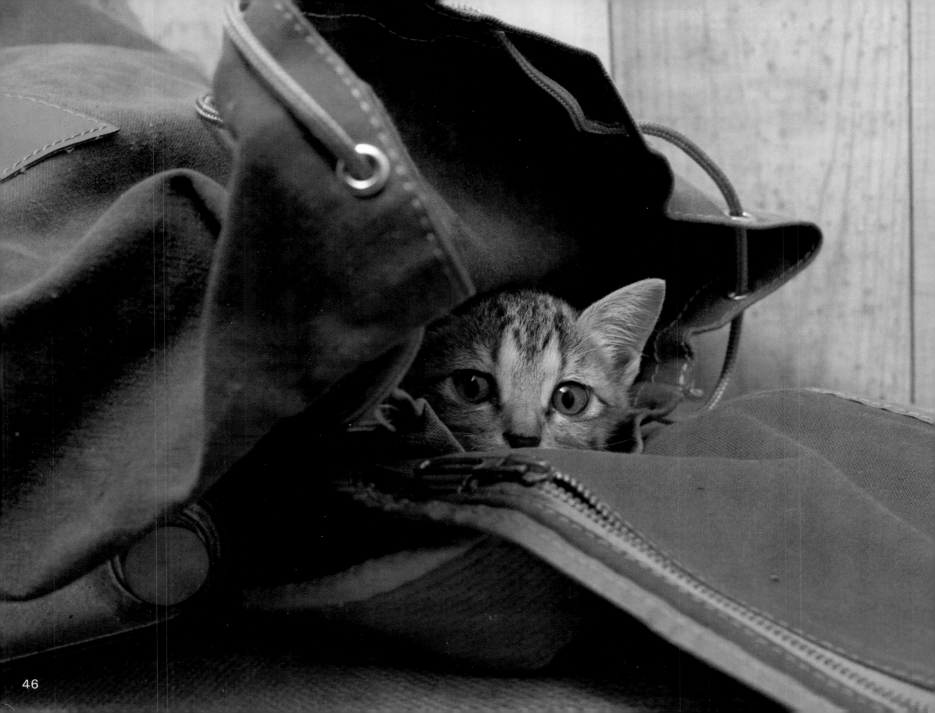

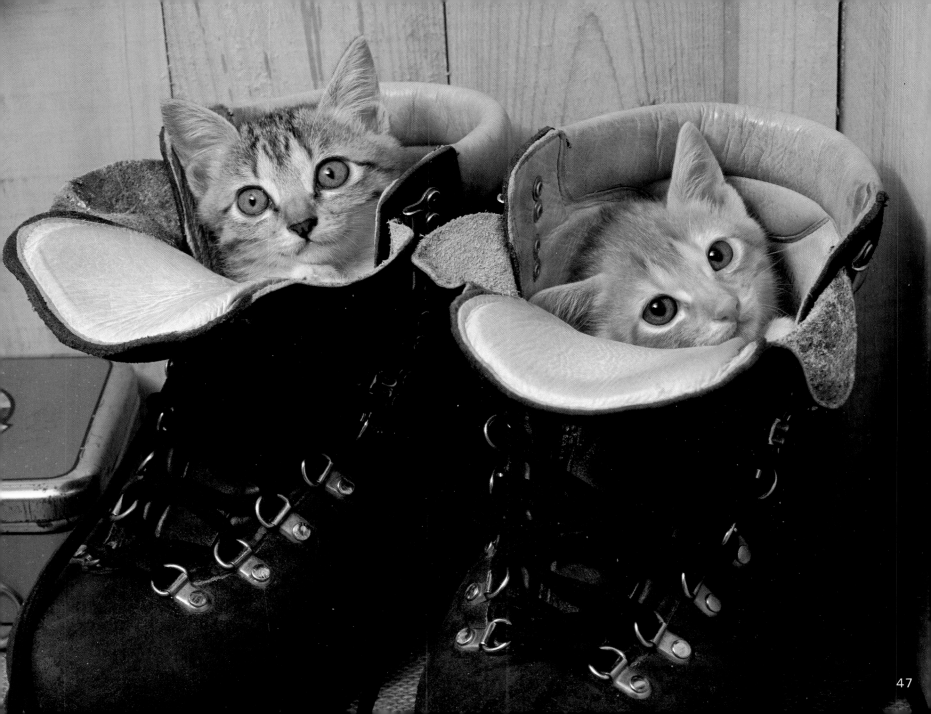

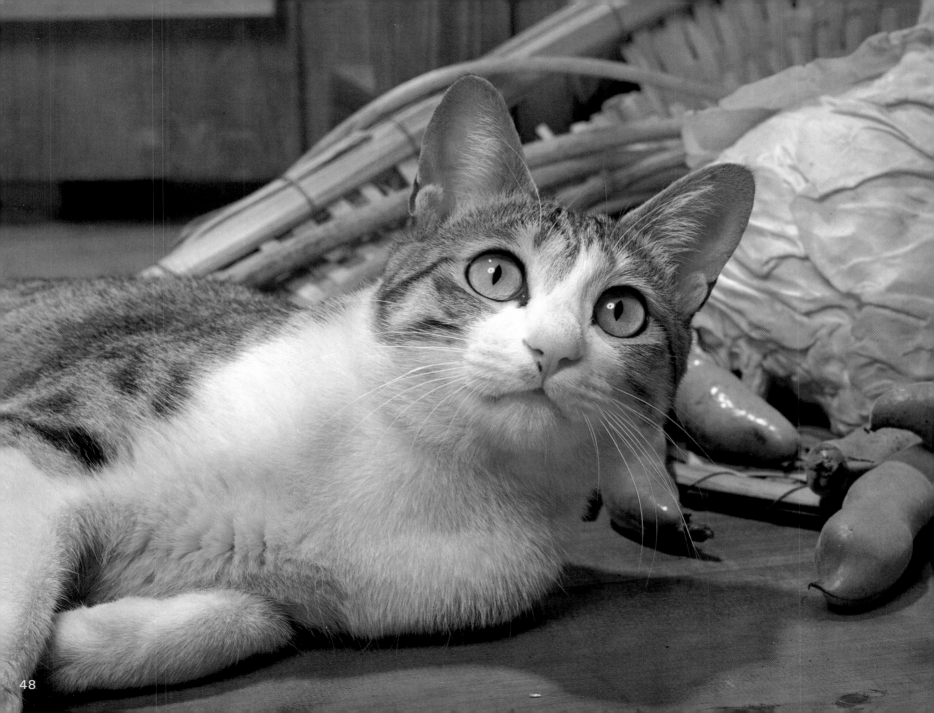

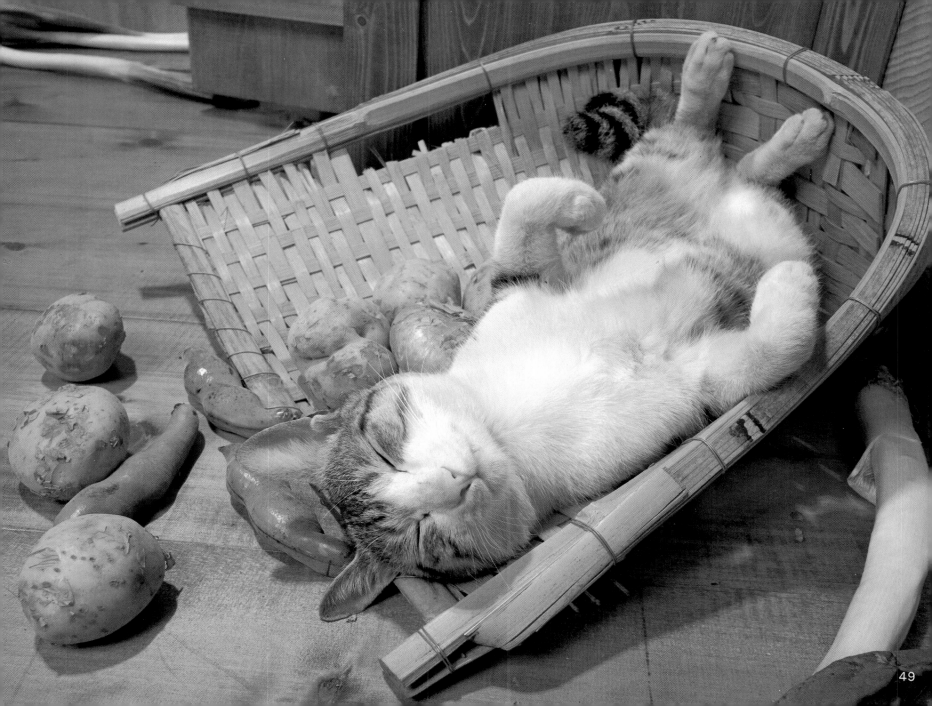

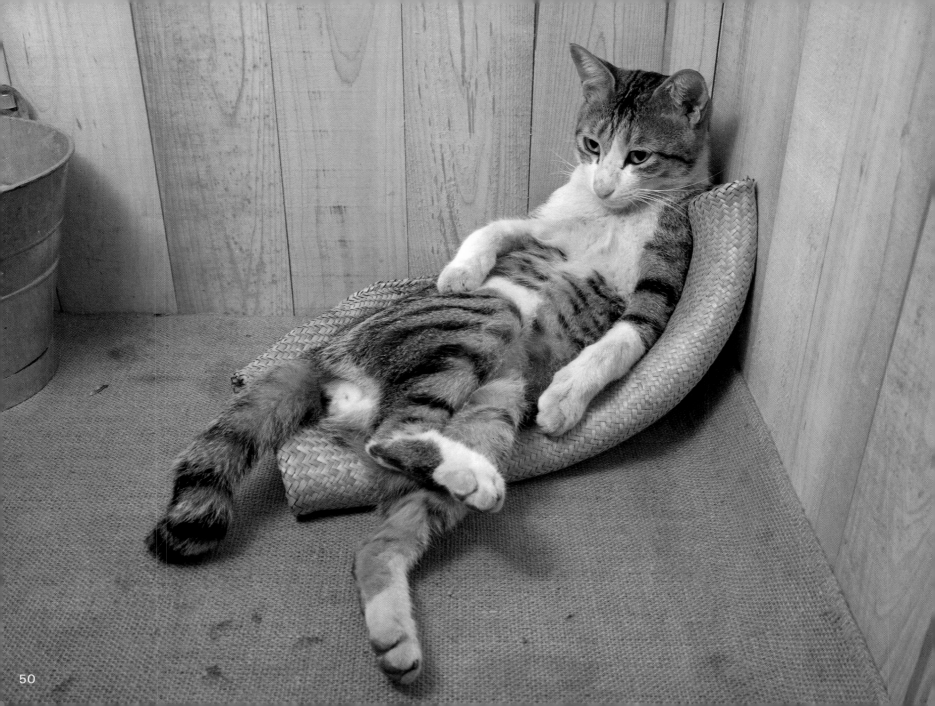

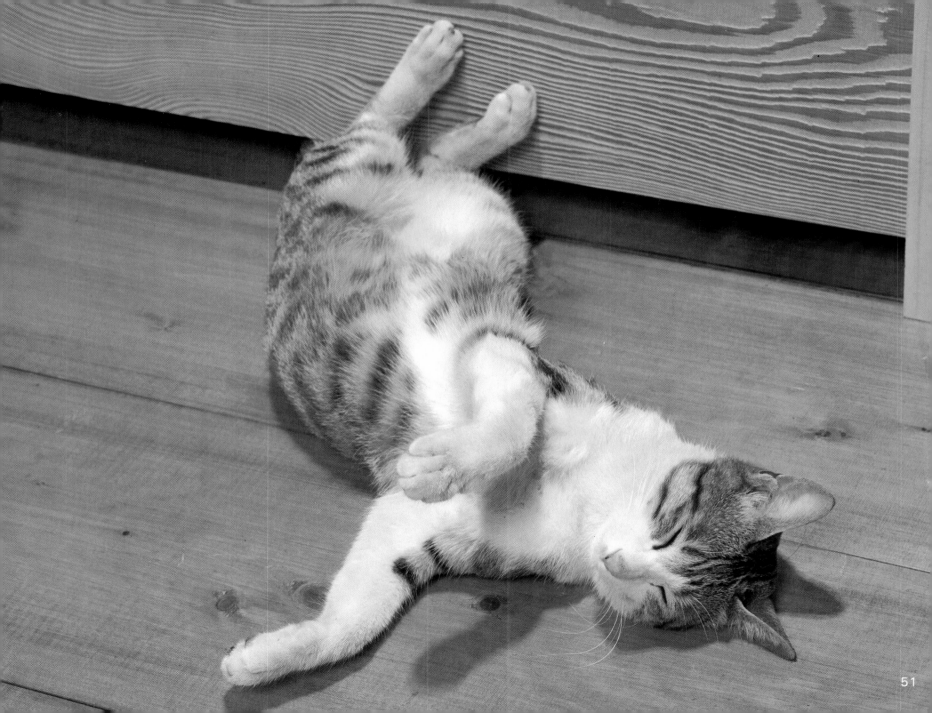

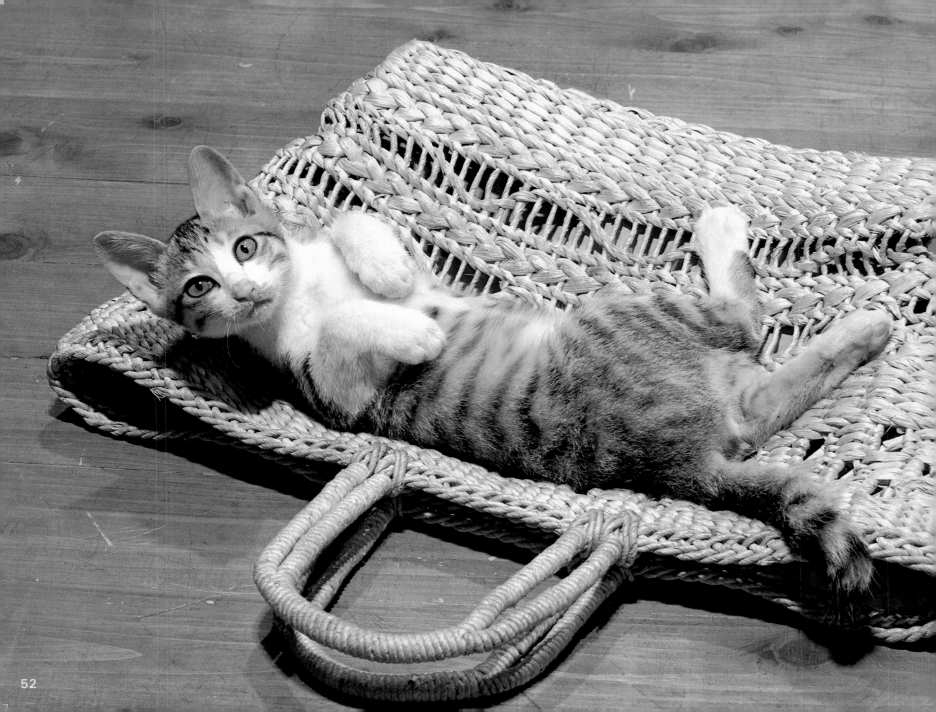

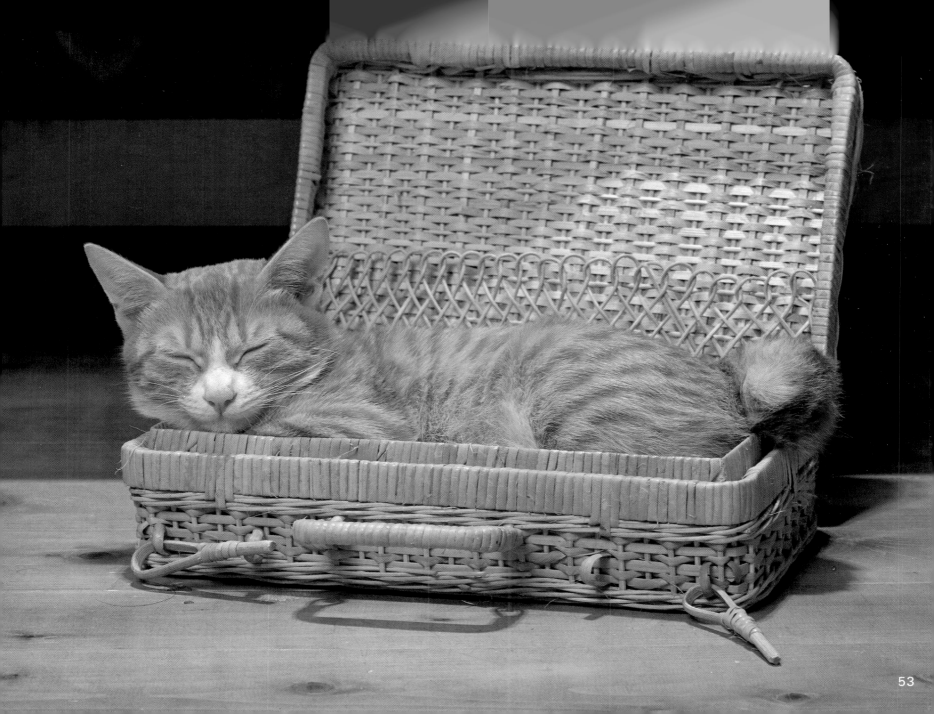

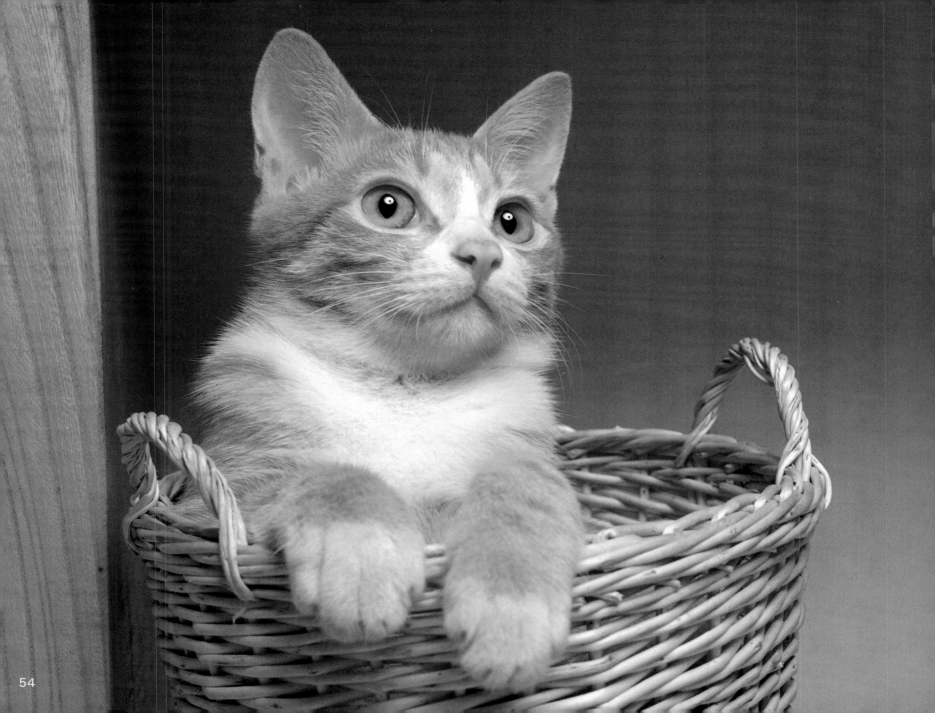

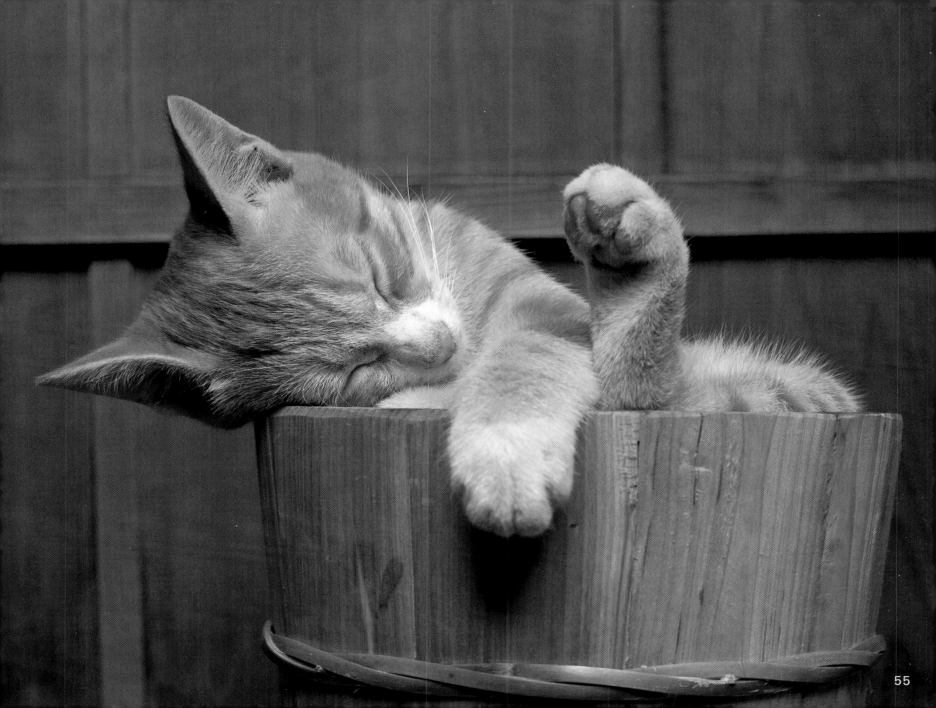

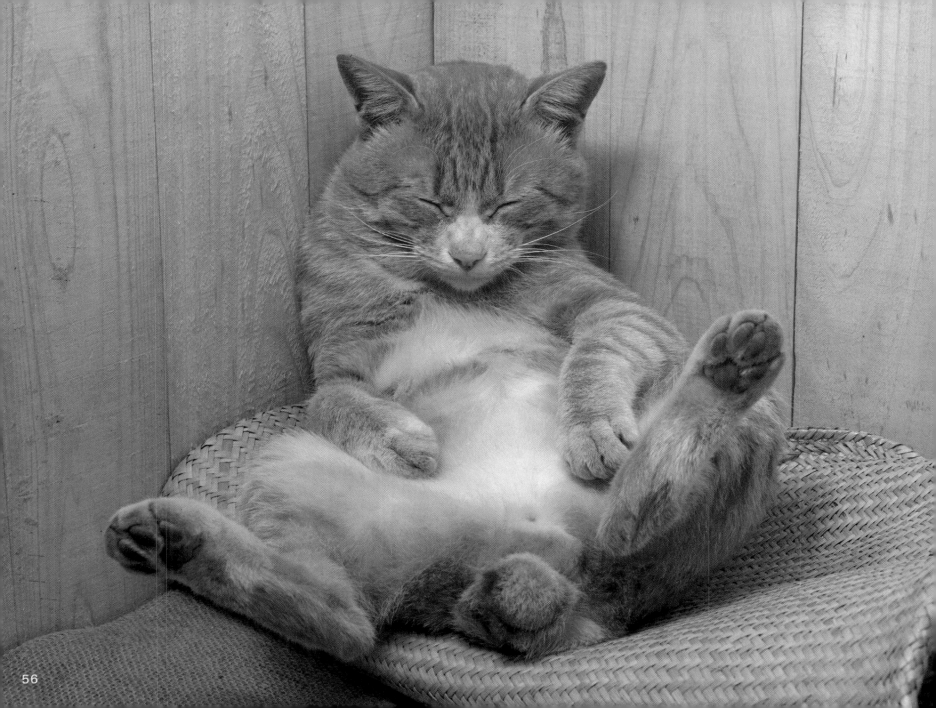

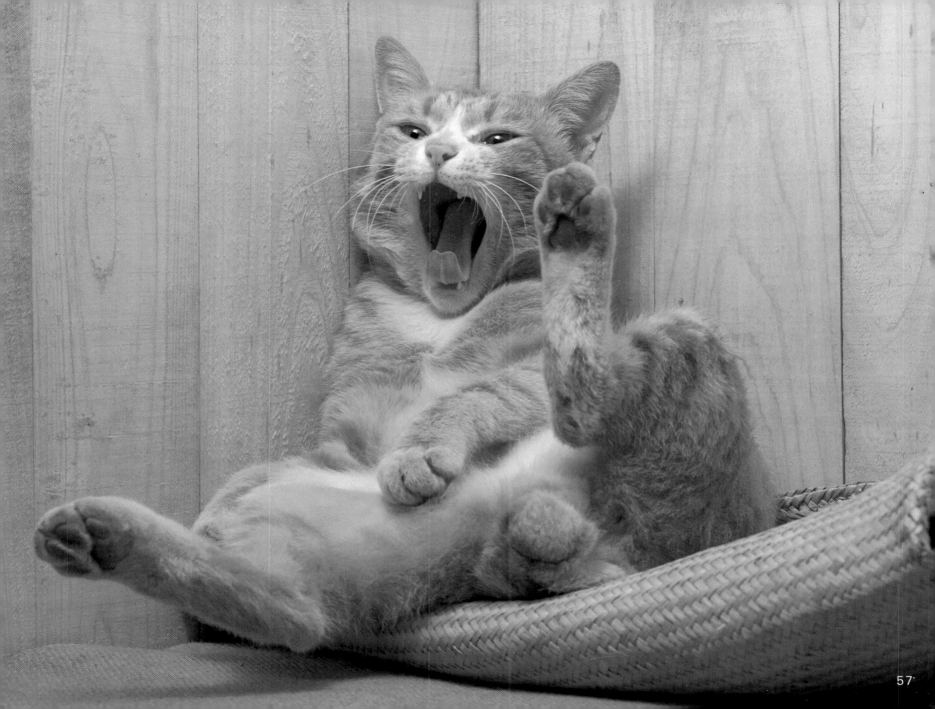

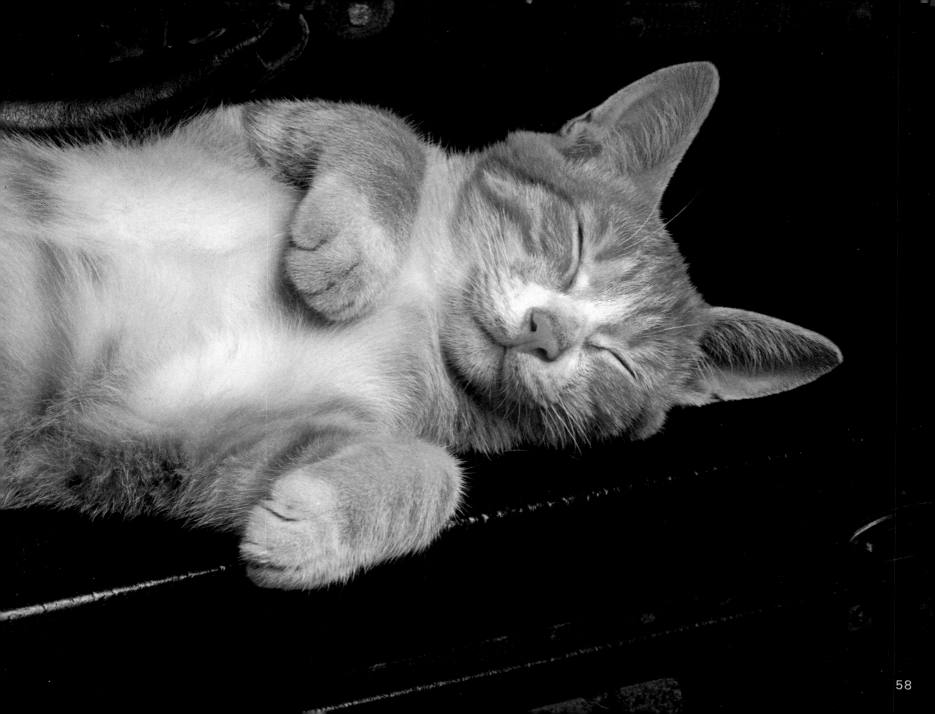

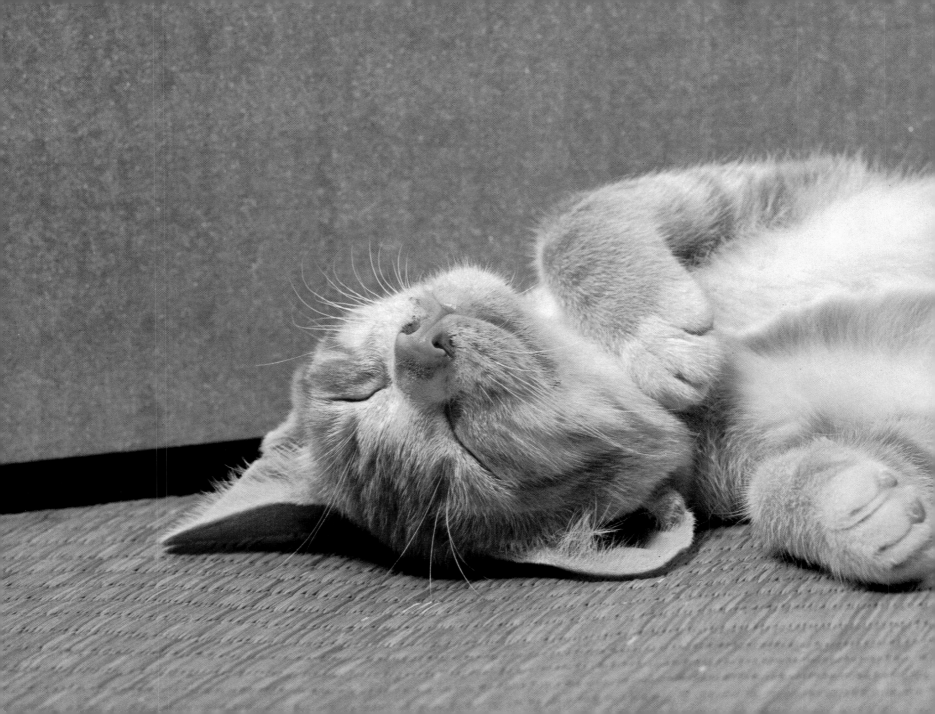

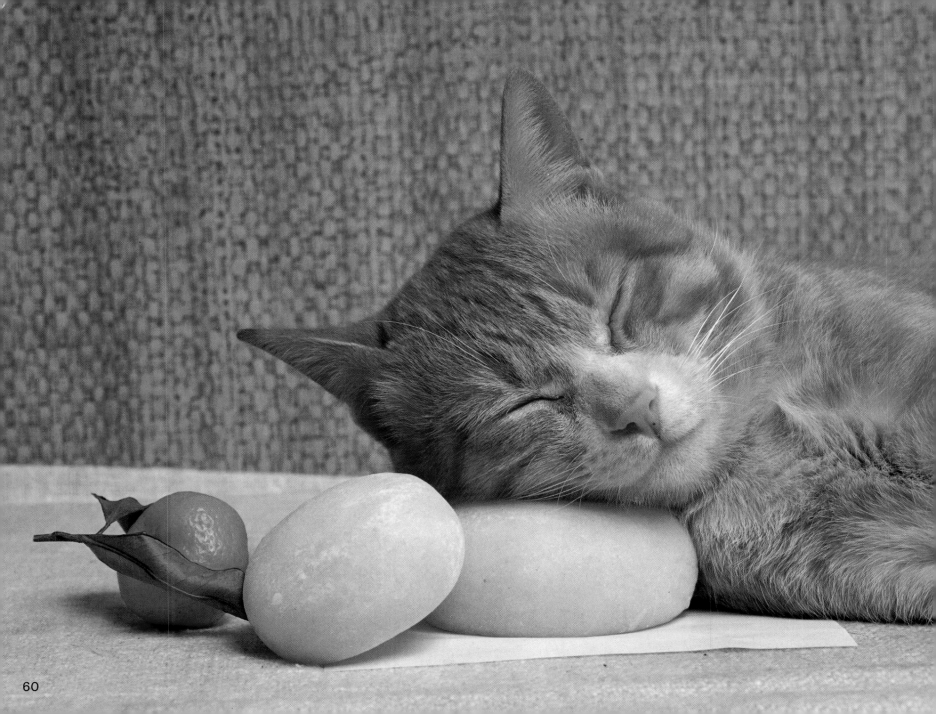